The Photographer's Guide to
EXPOSURE

The Photographer's Guide to
EXPOSURE

Jack Neubart

AMPHOTO
An Imprint of Watson-Guptill Publications/New York

For my dad,
whom I'll always love, admire, respect—and miss.

No book of this scope would be complete without acknowledging the many people and companies that lent their support, assistance, and cooperation, in one form or another. This support encompasses projects past and present that have contributed toward the completion of this work.

First, I have to thank the editorial team at Amphoto, and, in particular my editor, Susan Hall, for the kind guidance, support, and understanding that kept this project going through personal hardship.

Second, a number of photographic firms have provided me with technical assistance, equipment, film, and processing. These include: Agfa, Bogen, Canon, Duggal Color Projects, Eastman Kodak, Fuji, Ilford, Minolta, Nikon, Olympus, Polaroid, Sekonic-RTS, 3M, and X-Rite.

Third, I would also like to thank the magazine and newspaper editors I've worked with over the years.

And finally, I owe a special debt of gratitude to my friends and colleagues who have provided continuous and consistent support, as well as those individuals who took valuable time out of their schedules to model for me. These include my mentors and colleagues: Lee Drukker, Ed Meyers, Norman Rothschild, Elinor Stecker, and Barry Tanenbaum; the models: Patricia Freeman, Patricia Mainiero, Jacqui Sawiris, Marcy Sorkin, and Lisa Wong; and longtime friends Susan Gallagher, Renee Liberty, and Les Luchter. An extra-special thank-you goes to my friend Terry Zembowsky.

Copyright © 1988 by Jack Neubart
First published 1988 in New York by AMPHOTO,
an imprint of Watson-Guptill Publications,
a division of Billboard Publications, Inc.,
1515 Broadway, New York, NY 10036
Library of Congress Cataloging in Publication Data

Neubart, Jack.
 The photographer's guide to exposure.

 Includes index.
 1. Photography—Exposure. I. Title.
TR591.N46 1988 771.3'7 88-14216
ISBN 0-8174-5423-3
ISBN 0-8174-5424-1 (pbk.)

Manufactured in Japan

3 4 5 6 7 8 9/96 95 94 93 92

CONTENTS

Introduction

The politician, the celebrity, the local hero—each gets exposure, both good and bad. What one person sees as good, someone else may see as bad, and vice versa. It's relative. That's precisely the point.

Exposure *is* relative. There is no universally correct exposure. We can, however, define a correctly exposed photo as one where key highlights and shadows of the subject reproduce detail or texture as well as true tonalities and colors.

Making the "right" exposure involves an understanding of how light affects an exposure meter and how exposure meters work. It also involves both thought and shoot-from-the-hip reactions. Determining what is a correct exposure involves complex factors that come into play both when you take the picture and afterward, when the film is processed and when you look at the finished image. Releasing the shutter is the simple part. Each time you do this, you expose a frame of film to light. You make an exposure.

When you release the shutter, you might assume that the exposure was correct because you used an automatic-exposure camera. Perhaps it was. But can you be certain at the moment you take the picture? Also, can you tell even later, when you see the result? On the face of it, you can't if you accept your camera's exposure system as infallible.

There is a difference between an exposure that is correct and one that is the best suited to a particular purpose. In order for you to judge the suitability of the exposure to the image you are creating, you can apply certain criteria.

First, the exposure must meet the needs of the subject. It must record important subject tones and colors faithfully—or as faithfully as your film and your camera system can—along with key highlight and shadow details and textures.

Then, too, the exposure must suit the medium on which the image will be reproduced. A reversal film for transparencies ("slides") may require one approach for exposure; a negative material, another.

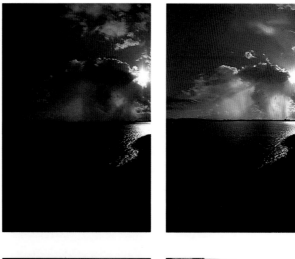

Each pair of photographs gives the subject less (photo left) and more (photo right) exposure. Which exposure is "correct" is a question I cannot decide or—rather, will not—answer. I have my own preferences, but I leave it to you to decide. Of course, not every subject lends itself to such openness of opinion, but many do. And that, after all, is the beauty of photography.

Furthermore, each type of film has inherent characteristics that affect the amount of contrast and the grain visible in the final image.

The exposure must also meet the needs of the end use. Images intended for the print media often require a different approach than those meant for exhibitions or slide shows. Subtleties in tone, color, and detail can be lost in print reproduction, for example, along with both extremes of contrast.

If you are a professional working with a client, the exposure must meet his or her needs. Most clients want to see the subject—the product, event or person—reproduced clearly and faithfully, with good color saturation and a full range of tones from highlight to deep shade. Deviations in exposing for the principal subject are rarely allowed.

Finally, if you are shooting for yourself, the exposure must suit your aesthetic preferences. In order to make the statement you want to with the image you visualize, you may need to emphasize certain tonal and/or color relationships.

The aim of this book is to help you choose the exposure that works best for the subject, for you, for the film used, for your camera, for the end use, and for the person who will scrutinize the result. My intention is to help you make the most of the tools at your disposal and to bring out the best in any image.

Many of the photographs that you see here were taken expressly for this book. With rare exceptions, I made the images with a 35mm single-lens-reflex (SLR) camera, either a Minolta XD11 or an Olympus OM-4T. Nikon and Canon systems have contributed to some degree, too. Despite my dedication to the 35mm format, the information presented here can be applied to medium-format cameras as well, because the latest in these designs incorporate the same electronics as 35mm cameras. Besides, photographers who use both these formats, as well as older models, rely on the same kinds of hand-held meters.

Because no two situations can be recorded exactly the same way at two different times by two different people, even using identical equipment, shooting data is provided only for general guidance and not with the expectation that anyone will duplicate the results. Unless otherwise noted, any exposure recommendations supplied refer to color slide film, the medium in which I prefer to work. Occasionally I have included reminders about making exposure corrections for other film types.

Whether you read this book before setting out or refer to it afterward to see why your exposures did not prove to be as satisfactory as you had imagined them to be at the time you made them, you should keep some notes to help in future situations when exposure may be a problem. Experience will be your best teacher. Sooner or later, you'll be able to discard those notes, or at least learn to rely on them less and less.

Sometimes, no matter how careful you were in making an exposure, you may look back at your collection of images and discover that the "wrong" exposure is the "best" one. Although this sounds paradoxical, you will discover as you read this book that there is no such thing as an absolutely correct exposure—not all the time, not for you as the photographer, and not for those who view the images you have created. Remember: correct exposure is relative.

TOOLS AND TECHNIQUES

You can't go anywhere today without confronting something or other that is computerized. This goes double for 35mm cameras. The microchips incorporated into today's automatic-exposure cameras give you through-the-lens (TTL) exposure-handling convenience that makes picture-taking almost as easy as pressing a button—although you could get away with simply pushing a button if you don't mind losing some of those precious or rare moments to poor exposure.

Bad exposures do happen. No matter how sophisticated the computer control in a camera's automatic exposure-measurement system, tricky exposures complicated by illumination, subjects, or scenes that don't conform to a camera's exposure programming can ruin a sublime image. You are left with only a memory of what might have been.

Many modern cameras are equipped with a variety of automatic modes for handling exposures; but there are usually in-camera overrides that give you some more control. These include manual autoexposure override and autoexposure lock. In fact, the camera may also be designed with a manual exposure mode—forever to operate exclusively in manual. This mode requires the use of either the camera's own metering system, in what is generally referred to as "match-needle" operation, or a hand-held meter—unless you are good at guessing or make use of the exposure tables supplied with the film. You can, however, also follow the "sunny-sixteen" rule, which states that when the bright sun shines over your shoulder, you can set the aperture at $f/16$ and the shutter speed at the reciprocal of the film speed.

There are other times when special hand-held meters are a preferable approach, if not your only choice, such as when you work with flash units that do not make use of the integrated exposure coupling in the camera's metering system. These meters are useful with portable electronic flash units that are not "dedicated" to the camera system you are working with. But they are more important when used with a manually operated flash, and in particular, with studio lighting systems. These meters also come in handy when you decide that one flash will not create the desired effect and opt for multiple-flash lighting. They also help when fill-in flash is necessary.

Experience accounts, in large measure, for successful exposures. This experience is founded on a working knowledge of and familiarity with various types of film, cameras, lenses, lighting devices, and shooting situations. It often involves knowing when to rely on the camera's metering system and when not to, especially under conditions for which the meter was not designed.

Through-the-Lens Exposure Control

This type of exposure control is the basis of all metering operations in single-lens-reflex (SLR) cameras today. Increasingly these metering operations involve automatic exposure control that is centered in the camera's microprocessor(s). Some cameras take through-the-lens (TTL) exposure control one step further by offering off-the-film or off-the-film-plane (OTF) exposure readings. Here, the amount of light entering the lens is measured off the film or off a textured shutter curtain. These readings are said to offer greater reliability, and some OTF systems are said to read light continuously as the exposure is being made, in order to take changing light levels into account and to adjust exposure even after the shutter is released.

Depending on the instructions burned into their computer chips, many of the newer cameras provide you with one or more metering options, ranging from a fully programmed mode to a variety of user-selected operating modes. These include aperture-priority or shutter-priority automatic modes and manual mode, with one or more flash modes added for even more picture-taking versatility.

Aperture-Priority Automatic Mode

In this mode, you select the lens aperture, and the camera's metering system sets a shutter speed, based on prevailing lighting conditions. With most of these cameras, once the shutter has been released, the camera-selected shutter speed remains in effect. Some models can, however, change the exposure time even after the shutter is released, in order to prevent the image from being overexposed or underexposed if there is a sudden shift in light levels. This mode of exposure control lets you determine how much of the scene in front of and behind the principal subject— or the point you are focusing on— will be in sharp focus because it gives you control over depth of field.

Aperture-priority operation can be used in various situations. In portraits of stationary subjects, you can throw an annoying background out of focus; in closeups, where depth of field is a limiting factor, stopping the lens down to a smaller aperture helps to make sure that more of the subject is in sharp focus. The camera warns you when the shutter-speed range has been exceeded in bright light. This tells you to set a smaller aperture.

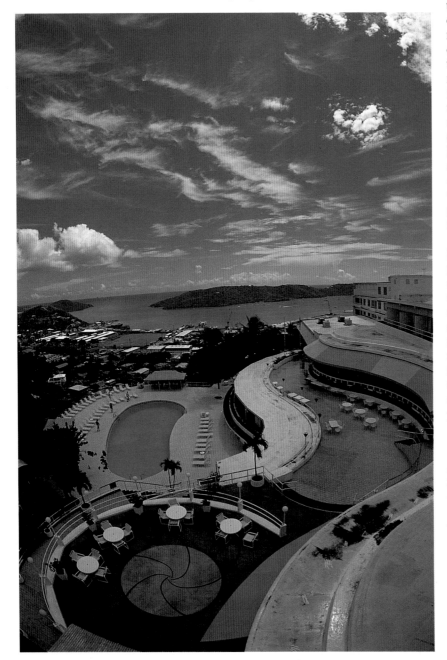

Through-the-lens (TTL) metering is a reliable way to measure exposure when you understand how the camera's meter works. Here, I set the camera to my favorite operating mode, aperture-priority automatic, and exposed as the meter indicated. This full-frame 16mm fisheye view from a hotel on Saint Thomas was shot at f/11, 1/250–1/500 sec.

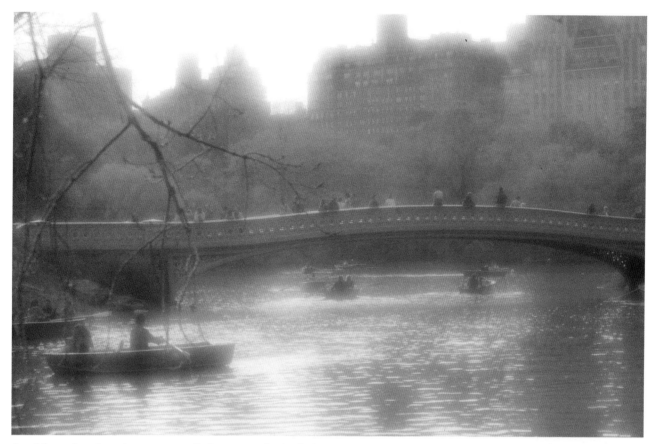

A soft-focus lens introduces a controlled amount of spherical aberration. As you stop down the lens, spherical aberration is reduced and maximum aperture is required to intensify the effect. For this shot of New York's Central Park, I opened the lens to its maximum aperture, f/2.8, and set the soft-focus control to its maximum as well.

DEPTH OF FIELD

This term defines the area in front of and behind the subject—or the point you focus on—that remains in relatively, or acceptably, sharp focus. This zone of apparent sharpness is directly influenced by three factors at the picture-taking stage: lens aperture, camera-to-subject distance, and lens focal length. If the other factors are equal, a larger aperture (for example, f/2.8) gives less depth of field, while a smaller aperture (such as f/16) provides a greater area, from front to back, where details have good definition. Similarly, greater focusing distances and wide-angle lenses provide more depth of field, whereas telephoto lenses limit it. Smaller focusing distances (as in closeups) limit depth of field,

and with macro lenses it is even less.

Most single-lens-reflex cameras have a control—the "preview" button—that lets you see how a change in the lens's aperture affects the depth of field at different focusing distances for whatever lens is in use. As you stop down to a smaller aperture, the finder screen dims, eventually darkening until it becomes difficult for you to see anything let alone judge image sharpness. This is because the lens is being stopped down to minimum aperture (often f/16 or f/22 on lenses for 35mm SLR cameras). When you view the scene at maximum aperture, or without pressing the depth-of-field preview button, you see only a narrow plane of

sharpness as you adjust the focus control. The scene appears to be sharper to a greater distance when you use a wide-angle lens, but this may be deceptive. You might think that the image is sharp when in fact it is not.

Some lenses, such as perspective-control (also called shift) lenses, operate with the lens stopped down to the picture-taking aperture. Here, the depth-of-field preview button on the lens must be depressed for you to get a correct TTL exposure reading and to make the exposure itself. Focusing must be done first, at maximum aperture, because stopped-down operation renders split-image or microprism focusing screens practically inoperative.

Because many autoexposure cameras don't have a shutter-priority mode, you need an alternative. Set the camera in the aperture-priority mode with an f-stop that will yield the fastest possible shutter speed to control movement. For this available-light portrait of a friend's five-month-old infant sitting inside a car, I chose an ISO 400 film. I set the lens at f/2, which gave me the necessary shutter speed, 1/125 sec.

For the picture below, taken at the New York Aquarium, I trained my 200mm lens on the suspended ball, set the camera in the high-speed program mode, squeezed the trigger gently, and waited for the whale to break the surface of the water. This mode ensured an action-stopping 1/250 sec., which guaranteed an image free of camera shake.

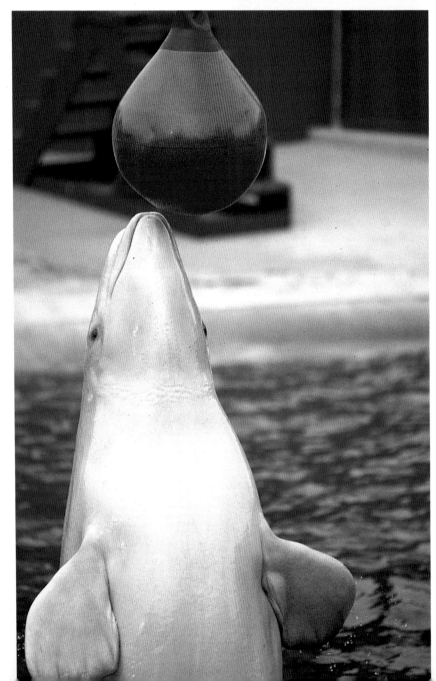

Shutter-Priority Automatic Mode

In this mode, you select the shutter speed; the camera then selects the lens aperture automatically. In this way, you can bias the exposure to shutter speeds that either stop action or blur the subject intentionally.

Unlike the aperture-priority mode, in which the range of shutter speeds is in a sense, almost unlimited, shutter-biased exposures are limited by the range of apertures of the lens in use. When the light is too dim for the shutter speed you select, the camera will either automatically select the most appropriate shutter speed that will work within that range of apertures or give you an exposure-error warning.

Program Mode

Spontaneous shooting does not often allow you the time to select either the right aperture or the best shutter speed, but the program mode sets both aperture and shutter speed automatically. This mode lets you shoot street candids without thinking about anything but the subject, especially if the action occurs suddenly. The program mode does, however, pose a problem when the situation or the camera equipment demands an approach that is biased toward either controlling depth of field or stopping action. In addition, for most programmed cameras, this mode assumes that you are using a 50mm lens and shutter speeds that do not drop below 1/30 sec. (If this happens, you get a low-light/camera-shake warning.)

High-Speed Program Mode

The standard program mode may prove inadequate when you use a telephoto lens. Because of their focal length and size, these lenses usually need a tripod or, when held in the hand, a faster shutter speed. The camera-shake warning in the viewfinder is usually inadequate. As a result, increasing numbers of programmed-exposure SLR cameras are being designed with a telephoto-lens bias. With this high-speed priority mode, the camera selects an aperture/shutter-speed

combination appropriate for the lens in use. Unfortunately, this mode does not take into account lenses that go beyond the short telephoto range (85mm to 135mm).

Low-Speed Program Mode
If you consider depth of field to be a priority, or if you work with normal or wide-angle lenses and regard faster shutter speeds as less important, you may want low-speed program operation. This mode sets the aperture/shutter-speed combination that is most suitable for shorter-focal-length lenses. It leans toward smaller apertures and relatively longer shutter speeds.

Metered-Manual Mode
Sometimes the camera's automated meter reading just doesn't "feel" right: it doesn't seem to allow you the creative control that would produce the most dramatic or most aesthetically pleasing image. Then again, perhaps you mistrust computerized metering systems or are uncomfortable with anything

that limits the amount of control you have. If so, you have another option: the full metered-manual mode. This lets you use the system's light-measurement capability to show an appropriate exposure setting, which you can override if you want to. The combination of aperture and shutter speed that you select will not change, regardless of changes in ambient light levels. This mode also gives you full control of the camera when you use a hand-held light meter.

Automatic-Exposure Override
When you have doubts about the efficacy of the camera's metering system and the resulting automatic exposure but you don't want to switch to manual (or your camera doesn't allow this), you can usually bypass the exposure manually with the autoexposure override. Whatever automatic mode the camera is operating in, the override enables you to increase or decrease exposure by half-stop or third-stop

I made this metered-manual exposure in a safari park while sitting in a car. I set the film-speed dial to EI 80 for this ISO 100 color negative film in order to have a slight exposure edge. The camera I used offered only match-needle manual operation.

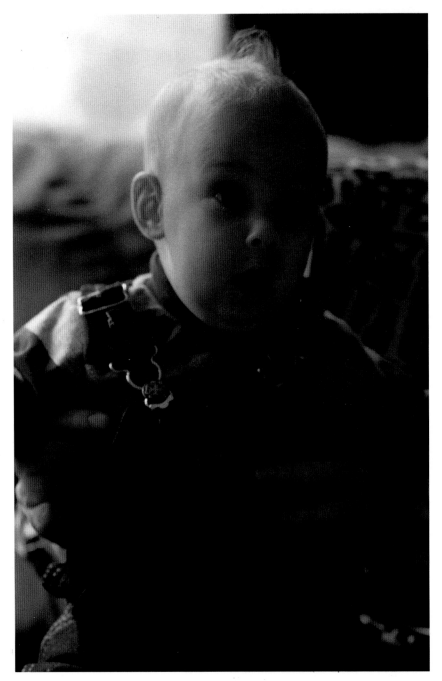

increments, usually to a maximum of two full stops.

Most cameras indicate in the viewfinder that the override is in operation. Unfortunately, it is possible to overlook the visual warning. An audible signal would be a nice option.

Autoexposure Lock

A number of autoexposure cameras provide control that falls somewhere between the metered-manual mode and fully automatic operation. Ordinarily, the exposure reading in the camera continues to change until the moment you release the shutter. If you meter carefully for a principal subject and then step back to compose the shot, the automatic meter reading most likely changes. As a result, your carefully planned photograph will probably be ruined. On the other hand, with an exposure lock, you can take the same reading and hold it, step back, and then release the shutter to achieve the exact metered exposure you planned. It's that simple.

Why not just switch to manual? The autoexposure lock is unnecessary if you are working in the manual mode, of course. But the lock eliminates the need to switch operating modes continually from automatic to manual and back again. The exposure lock gives you manual control in the automatic mode. If a situation calls for an immediate reaction, you're ready. Be sure to cancel the setting after taking the exposure (if it does not cancel automatically as soon as the shutter is released).

Backlighting can pose a problem for any TTL exposure since it causes the meter to underexpose the principal subject. For this shot, opening up about one stop over the initial exposure of f/4 at 1/125 sec. did the trick. I chose to be practical here, basing exposure compensation on the shutter speed I needed to avoid camera shake with a hand-held 90mm lens. A table lamp nearby helped to highlight one side of the baby's face as well.

Through-the-Lens Metering Patterns

The light-measurement systems built into cameras are designed to read the amount of illumination present in any scene. The metering cells are more sensitive in certain areas, which differ according to the design of each camera's system. Most commonly, these are center-weighted averaging patterns, but some are spot-reading as well.

Center-Weighted Averaging

This metering pattern considers the center of the viewfinder to be the place where the principal subject appears, but it also considers the outer area in a more or less concentric pattern in diminishing degrees. In some cameras, the sensitivity pattern is based on the assumption that the camera will be held horizontally with the sky in the upper portion of the viewfinder; it therefore places the least emphasis on the uppermost area of the viewfinder. As a result, when the camera is held in a vertical position, the zone of least sensitivity is elsewhere than the meter assumes it to be. This can lead to exposure error if the important subject is in that area.

Spot Sensitivity

This metering pattern allows you to bias an exposure to a key subject area, such as a skin tone, a highlight, or a shadow.

These two photographs, shot at New Jersey's Brigantine National Wildlife Refuge, were made within seconds of each other, with the lens stopped down to minimum aperture to create the starlike effect. Why are the exposures different? This is a result of the center-weighted sensitivity pattern. The sun is less centralized in the lighter vertical shot and affected exposure less than it did in the horizontal picture.

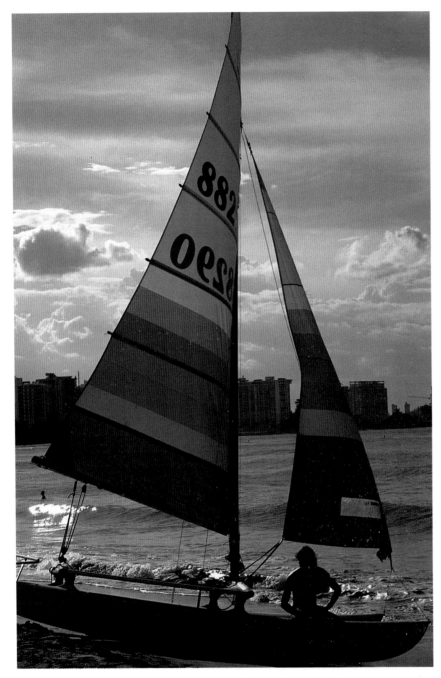

In this shot of a sailboat in San Juan, I wanted to capture the deep color in the sky and in the sails on the boat. I let my camera's TTL metering system dictate the exposure.

Consequently, cameras with spot metering give you, perhaps, ultimate control over exposure. The area of sensitivity varies with the focal length of the lens. It concentrates on an area outlined in the central portion of the finder. Usually this is also the area occupied by the split-image rangefinder or microprism focusing device. In other words, the longer the lens's focal length, the more well-defined the spot being measured.

Highlight Bias and Shadow Bias

In this variation on traditional spot-metering you can weight the exposure toward the highlights or toward the shadows, thereby preventing possible underexposure or overexposure, respectively. The procedure involves an additional metering step: After putting the camera into spot mode, direct the finder area designated for spot readings at the highlight or shadow, and then push a button to add two stops exposure (for highlight bias) or reduce exposure by about the same amount (for shadow bias).

Multiple-Spot Averaging

When you spot-meter selected areas, you can take multiple readings and average them for the final exposure. But it's up to you to remember what those readings were. Cameras with multispot averaging go one step further. They let you make a number of spot readings for a final exposure, then the internal computer does the calculations for you and automatically provides the averaged exposure. This means that if you find a scene with several important highlight and shadow areas, you can expose for these in particular. Why not just meter the key (most important) highlights and shadows and average the two? Because you might want to weight the exposure in favor of a group of subject tones, even if this means de-emphasizing the tonalities at one or both extremes.

I came across these models showing off boutique fashions in Old San Juan. Because of the high contrast, I spot-metered the red dress with the camera's spot mode, then made the exposure.

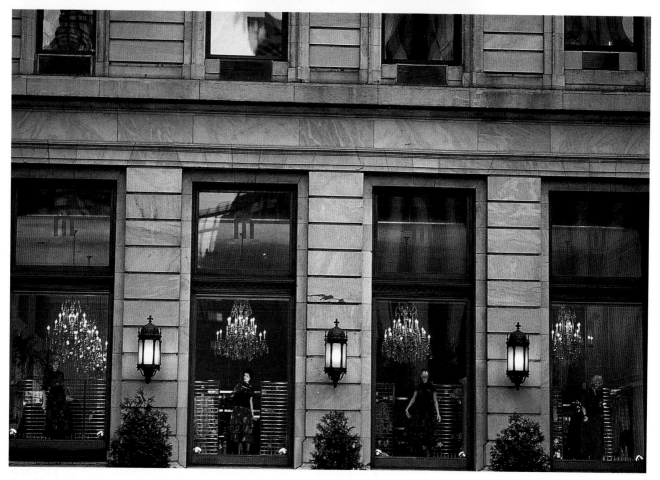

For this shot of New York's Plaza Hotel, I used my camera's multispot-metering capability to take readings from across the street of the chandelier inside the window (1/125 sec.), a mannequin (1/30 sec.), and a lamp outside (1/30 sec.) The camera's computerized brain did the rest.

Assuming that the brightness of this building would result in underexposure with a conventional TTL exposure, I made one spot reading off the bright façade (f/5.6, 1/500 sec.) and another of the shadow side (f/5.6, 1/60–1/125 sec.) using the camera's multispot-metering mode, and let the camera average the two. As it turned out, the center-weighted exposure proved to be practically the same.

PRESERVING BATTERY POWER

Cameras that have integral metering systems operate off battery power and may be totally inoperative when the battery fails. Other cameras may provide a fail-safe mechanism in the form of one or more mechanically governed shutter speeds, so that even if the battery fails, you can still make an exposure. You may be limited to a less-than-optimum combination of aperture and shutter speed to give you the effect you wanted, but at least you can take the picture, even if you have to guess at the exposure. It is always a good idea to carry spare camera batteries—and a separate exposure meter.

On most cameras made today, pressing the shutter release part way down activates the metering system, but with some you may have to switch it on yourself. In either case, keeping the metering system in the "off" position, by means of either the shutter-release lock or the activation switch, will ensure longer battery life. If you are using a camera that does not have a preventive lock on the meter-actuating shutter release, be careful when you pack it in the camera bag. Avoid piling other items on top, or you'll find that pressure on the release button has drained the battery. True, this rarely occurs. But the unexpected does happen.

Multiple-Zone Averaging

This metering pattern is also called multiple-pattern averaging. In this method, the camera's light-measurement system automatically reads selected areas of the scene and, disregarding areas of extreme contrast, determines the correct exposure. As a result, scenes with very bright sources of light, such as the sun, are not unduly influenced by the source and underexposure of the foreground subject is prevented.

Multizone averaging differs from multispot averaging in that it is fully controlled by computer. In some camera models, overrides may be available. Usually, though, multizone metering allows you no direct control over how the exposure measurement is made. On the other hand, with multispot metering, as with manual operation, control does rest with you.

Electronic Flash

There is a wide array of studio flash equipment that offers control and efficiency unmatched by any on-camera system. Since TTL flash is becoming the norm in today's 35mm SLR cameras, however, it makes sense to begin there. Some flash units are portable and small enough to be mounted directly on the camera's hot shoe or on a bracket attached by way of a cord to a socket on the camera body.

Today, the use of speedlights—portable electronic flash units—with 35mm reflex cameras is taken for granted. In fact, technology has advanced so that the increasingly prevalent norm is an electronic linkup between the flash unit and the camera. This "dedicated" circuitry automatically sets the camera's shutter to the "flash-ready" mode, and at the correct synchronization speed for that camera-flash unit, when the unit's capacitor has reached full charge. An indicator in the viewfinder tells you when the unit is fully charged. Another indicator—or the same one—shows you afterward that the light that was emitted will produce a properly exposed image. These viewfinder indicators differ from one camera model to another. They let you work with flash without taking your eye away from the viewfinder—unless you need to do so to advance the film manually. There is one drawback to this technology: it operates with maximum automatic efficiency only with the camera system for which it was designed—that is, dedicated.

A further advancement over basic dedication is TTL flash. Here, exposures are based on light readings taken not simply through the lens but actually off the film or at the film plane for more accurate flash exposures under a wider range of illumination. TTL flash is becoming the norm in 35mm SLR cameras.

TTL Automatic Flash

Reading flash illumination levels correctly can be tricky. The use of filters, extension tubes or bellows, teleconverters—anything that

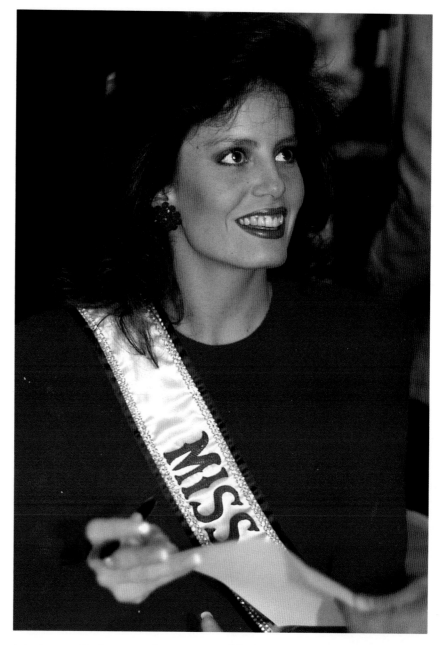

interferes with the normal exposure equation—can prove fatal to a flash exposure. Moreover, you are usually limited by the aperture selected. That's where TTL automatic determination of flash exposure comes in handy. TTL automatic flash reads the amount of light that enters through the lens—this is the same as for any TTL exposure using ambient light. What differs here is the presence of a photocell dedicated to reading the flash from the speedlight. It can read the light from one flash unit or from several similarly designed units fired simultaneously with the aid of a dedicated multiple-flash sync cord.

Miss Universe 1987 was signing autographs indoors. The available light was insufficient, and all I had with me was a dedicated portable flash, which I mounted on the camera's hot shoe for this candid portrait.

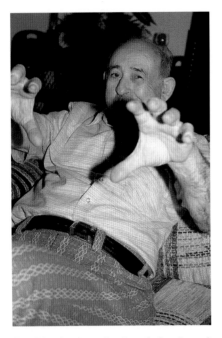

For this photograph of my father, I used TTL automatic flash, which simplifies exposure. But with an on-camera flash, problems can occur, such as intrusive shadows from foreground subject areas—here, my father's hand.

Outdoors at night, where direct flash is the only practical form of light, you can get good results with a subject close by. For distant subjects, you may have to increase exposure because of the lack of reflective surfaces to bounce some of the light back. This exposure was made at f/5.6.

Because these units are dedicated electronically to a particular camera system and are controlled through the camera's own microcircuitry, they put many functions within the photographer's reach. In addition, all the exposure information—besides flash-ready and correct-exposure confirmation—is provided in the viewfinder. The camera automatically senses when the flash is ready and, if it is not, will return to its preexisting mode of operation to make the exposure.

TTL flash can take advantage of all the latest in exposure programming. It can operate in various modes: TTL aperture-priority, TTL shutter-priority, or TTL program. This depends on the camera's design, of course. Autofocus cameras offer additional TTL modes that integrate the camera's automatic-focusing feature, for instance, and some systems can manage fill-in flash for backlighted subjects.

Another enhancement of TTL technology is the incorporation of a built-in flash above the lens, on top of or in front of the pentaprism housing. However, this flash unit does not offer you the power, recycling speed, or versatility of a separate unit. But it does have the virtues of convenience and compactness.

Automatic Shoe-Mount Flash

This traditional on-camera flash unit operates independently of the camera. Although the camera's hot shoe provides a contact point, it is often an electrical, not an electronic, connection and serves only to trigger the flash when the shutter is released.

This kind of flash unit bases its automatic exposure on the amount of light reaching its autosensor, a photocell on the flash itself. You must point the autosensor at the subject for a correct reading: It does not "see" any filters or lens extensions that might affect exposure. These units work best in a medium-sized room, where there are walls to reflect light back onto the subject; using an on-camera automatic flash unit for a distant

subject outdoors with no additional ambient light can result in underexposure. More advanced automatic flash units permit the head of the unit to rotate and tilt while the photocell stays aimed at the subject. Other units take this one step further by permitting the sensor to be mounted independently on the hot shoe while the flash is positioned on a bracket or off the camera.

Dual Flash

While most flash units have a lone flashtube, some incorporate a second, lower-output flash. The purpose of this subflash is to add fill-in light while the primary tube is being aimed away for bounce lighting. The fill-in light eliminates the need for reflector panels by lightening or "filling" shadows that can be intrusive when bounce lighting is used. In a portrait, for example, when light is bounced off the ceiling, pockets of shadow form in the eye sockets.

Dedicated Automatic Flash

An option that falls between full computer control by the camera and simple automatic operation within the flash unit itself is the dedicated automatic flash synchronization mentioned earlier. Here, an electronic contact between the flash unit and the camera hot shoe sets the shutter to the proper electronic-flash sync speed as soon as the unit has charged itself up. It also activates a flash-ready signal in the camera's viewfinder.

While the dedicated flash may not have as many contact pins at the bottom of its "foot"—the part that fits into the "shoe" on the camera—as a TTL autoflash does, it has more than the single one ordinarily required for basic on-camera automatic flash. The contact point can also be made through a dedicated sync cord designed to slip into the camera's hot shoe instead of a separate outlet for dedicated off-camera operation.

In any dedicated system, the use of a speedlight with contact pins that do not match those on the camera can lead to an electrical

short. Whether or not that is likely with a dedicated TTL flash made by an independent manufacturer is uncertain (but I'm not about to experiment, and I recommend that you don't either). It just might be safer to follow the camera manufacturers' warnings and use their matched units. Manufacturers of dedicated TTL flash systems take this dedication very seriously, warning against the use of any flash unit not designed by them. (Note, however, that there is a European standard dedicated-flash technology that offers full compatibility between independently produced units and some European-made cameras.)

Another potential problem with TTL flash dedication is that not every TTL flash camera has a standard PC socket for nondedicated operation (that is, X-sync for electronic flash). Without this PC contact, you won't be able to hook up a studio flash to your camera. The camera manufacturer may, however, offer an accessory that lets you plug a standard PC cord into the system for nondedicated, manual operation. Because the PC contact bypasses the camera's electronic circuitry, the correct X-sync speed for this flash must be set manually.

Manual Flash
A correct flash exposure depends principally on the distance between the source of flash illumination and the subject being illuminated. There are times when, given the range of available apertures or existing light conditions, you must bypass automation and go to manual mode to ensure a correct exposure or to produce aesthetically pleasing images. Indeed, while a scant few strictly manual flash units are sold in photographic specialty stores, manual control fortunately continues to be offered.

Among the advantages of manual operation is greater predictability: Depending on the unit's design, it gives you a fixed output of light. In automatic operation, the flash output can vary between, say, 1/1,000 sec. to 1/50,000, sec., depending on the amount of

illumination needed. If more light is required for a given aperture/distance combination, then a longer flash duration is provided by the automatic unit; the reverse happens when less light is needed. A unit operating in manual emits light only at whatever flash duration has been designed into it, for example, at 1/1,000 sec.

Variable-Power Output
Quite a few on-camera flash units are designed to vary their output to meet unusual demands. This can be done in automatic or in manual mode, or in both; it may also affect the flash duration when the output control is set at a fractional value. For example, the variable output settings may range from full power to 1/16 power; at 1/16 power, the flash duration may be shorter.

The reason for variable output is simple: suppose the lens aperture that you have selected would let in too much light for correct exposure at your chosen flash-to-subject distance. By lowering the flash output, you avoid overexposure. This feature is especially helpful in using the flash for fill-light.

The Calculator Dial
When operating a conventional flash unit in automatic or in manual mode, you can find the appropriate f-stop after deciding on your flash-to-subject distance and focusing, by reading the stop off the calculator dial or scale usually found on the back of the flash unit. There are no actual calculations for you to make. In the automatic mode, just make sure that the distance range shown on the calculator scale covers the distance you have set on the camera's focusing ring. If your subject is beyond the outer limit of that range, there will not be sufficient light output, and the subject will be underexposed. If the subject is closer than the range covered, it might be overexposed. (I say "might" because once a flash is used too close to the subject, well short of its near-limit indication, the efficiency of the flashtubes is lessened to about half.) Usually, the near limit for a flash is little more than 2 feet (70cm). The only

situations where you might want to violate this minimum-distance boundary are closeups.

A flash unit's own calculator scale can be used with the manual mode to find the correct f-stop to use at the flash-to-subject distance you have selected. One advantage here is that you could use a larger aperture to allow a greater flash reach than would be possible if the unit were operating in the automatic mode. Another advantage of manual is that the variable-output feature can be operated solely in this mode. Furthermore, manual may be the only practical approach for controlling flash-fill.

These descriptions of manual and automatic flash modes make certain assumptions; principally, that the flash is on the camera, and that the focusing distance is the same as the flash-to-subject distance. When you use the flash off the camera, check the actual flash-to-subject distance and compare that figure to those on the calculator dial. Make any necessary adjustments in your f-stop or power settings.

Flash calculators can take the form of a calculator dial or a kind of slide rule. Both indicate the appropriate flash range for each aperture at a given film speed. Also note the output ratio control, which lets you cut back on the unit's output for different applications. Some flash units offer variable output in the manual and automatic modes.

Guide Numbers

These are no longer put to much practical use, except to check on the actual output of a flash unit. Essentially, a guide number (GN) expresses the relationship between an *f*-stop and a flash-to-subject distance and is used as a means of rating the strength of the flash unit. With studio electronic flash units, guide numbers are also related to the units' reflectors—certain reflectors have higher guide numbers than others and so give out more light in a concentrated form.

Guide numbers apply only at normal flash-to-subject distances, with standard flash reflectors (usually built into on-camera units) and normal-sized rooms with fairly reflective walls. Guide numbers of light sources are usually given for a film speed of ISO 100, but manufacturers may have calculated in meters rather than in feet. For example, a flash unit with a GN of 33 in meters would be equivalent to one with a GN of 100 in feet at the same film speed, ISO 100.

Studio Flash

It is true that a number of shoe-mounts and, in particular, handle-mount flash units offer a lot of punch for their size. But they are not as versatile or as controllable as studio units. And studio strobes do offer more power. Unlike so-called tungsten/quartz-halogen studio lamps, studio electronic flash heads do not generate great amounts of heat. As a result, people are more comfortable sitting under them, and you can control them more easily, with little or no fear of burning your hands on hot metal reflectors when you reposition them.

Electronic studio flash equipment comes in two basic forms: self-contained monolights and power-pack systems. Self-contained units have power sources built in and, in most cases, are independent of any other units being used except when triggering devices are used to fire additional "slave" units. Control over the output resides in the built-in power supply. Power-pack systems centralize control in a separate power supply that can

This is a self-contained monoflash. The power pack is built into the flash head. This unit features full- and half-power output. Some monolights offer a wider range of variable power.

handle two, three, four, or even more individual flash heads; the number accommodated depends on the design of the pack. Unlike monolights, each of which plugs directly into an AC outlet, power packs and not the separate flash heads are connected to the outlet.

Studio flash units provide the utmost in control and convenience indoors. They can be used with all sorts of light-control devices, and this can make them more efficient than any available for on-camera use. They are equipped with "modeling lights" that let you see the effect of light placement on the subject before you make the exposure, so you don't waste any film or valuable time. Because the modeling lights are proportional to the flash output, lighting contrast becomes easier for you to control, as well, along with the ratio of light supplied by a key flash and that by secondary lamps.

Some Final Flashes

Sync cords can get frayed or lost. If you use them—and you will for anything other than hot-shoe or dedicated on-camera flash operation—keep a spare handy. This is especially necessary with dedicated cords because they are not interchangeable between camera systems. Furthermore, cords, especially standard PC cords, often pull free of the

camera's socket when the unit is used with an off-the-camera flash. Some cameras provide more protection against this possibility than others do, however, and you may find that dedicated sync cords eliminate the problem entirely.

With SLRs with focal-plane shutters, to expose a frame of film fully by light from an electronic flash source you must set the correct synchronization speed on the camera. This is not a problem with dedicated systems—they do it for you. But when this must be done manually, setting the camera to a faster shutter speed than its X-sync speed will result in, at best, having only part of the frame correctly exposed. The other part will be either underexposed (if there was some but not enough ambient light) or totally black.

Finally, on-camera flash systems are generally designed to cover the field of view encompassed by a 50mm lens on a 35mm camera (or the equivalent angle of view in another format), although some systems do cover the slightly wider field of view of a 35mm lens. When you use a lens of a wider angle, the image will be vignetted because the flash illuminates only the area that it was intended to cover. To prevent this, use a "wide" accessory panel or diffuse the light some other way to spread it over a greater area.

Hand-Held Meters and Technology

The design and technology of these instruments have been greatly altered with the advent of the electronic microchip. Although many photographers now consider older meters to be "primitive," there are die-hards who prefer them. Almost every advanced-feature hand-held meter currently produced is controlled by a microprocessor, and most have digital liquid-crystal displays (LCD).

Both older meters and new, less expensive models are driven by an electrically charged galvanometer-coil movement. The power is supplied by either a photoelectric cell alone or a battery-boosted photocell. Most often, the galvanometer movement is evident in a needle whose position shifts in response to changing light levels. The needle points to a number on a scale. This number may have been arbitrarily assigned, or it may be a standard exposure value (EV). This number serves as the guide for determining the combination of lens aperture and shutter speed appropriate to a given film speed.

The most basic light-sensitive device is the selenium cell. Because it is independent of an outside power source, it serves well when batteries are hard to come by. Meters made with this type of cell can be used as backup. The major drawback to selenium-cell meters is their relative insensitivity to low levels of light.

The cadmium sulfide (CdS) photocell ushered in the next generation of light meters. It is more sensitive to all light levels. It depends on batteries and can be sluggish in dim light. The CdS photocell also can be temporarily "blinded" by extremely bright light because it suffers from something called "memory." This memory, which can result from sudden or prolonged exposure to very bright light, keeps the meter from operating properly for a period up to several hours. In practical use, I haven't encountered any memorable problems.

The newest photocells to be incorporated in exposure-meter design are the silicon blue cell (SBC), often referred to as silicon photodiode (SPD). Like CdS cells, they depend on batteries; however, they do not suffer either from sluggishness in low light or from memory but respond almost instantaneously to changes in the light level. Although another type of photocell, the gallium photodiode (GPD), has been introduced into a handful of SLR cameras, it has not been used in hand-held meters because it is expensive and has shown little advance over silicon cells.

To all meters, light is light. Exposure meters cannot tell which areas are important to the picture, which are too light, too dark, or just right.

In addition, meters can be unduly influenced by either bright areas or dark areas in the scene. The reason? All exposure meters are keyed to a standard reflectance equivalent to that obtained by a "reading" or measuring the amount of light bouncing off a neutral-gray card, that is: 18 percent reflectance. This is true whether the meter is of the reflected-light averaging, spot, or incident-light type. This applies equally to a meter that is integrated into the camera design and to a separate hand-held meter.

Deviations from this 18 percent neutral-gray averaging of the light that falls on the real world are what cause pictures or parts of pictures to be either underexposed or overexposed unless the photographer makes adjustments before releasing the shutter.

Deviations also occur to some degree in all types of meters themselves. The amount of deviation is determined by the angle of acceptance of the photocell and by what illumination is being measured; that is, whether it is reflected back by the subject or is incident to the scene, falling equally on everything the lens sees.

Reflected-Light Meters

These are the most basic exposure meters. They read light reflecting off the subject or scene, the same as in-camera metering systems. They are also called reflectance averaging meters. With the photoelectric cell directed at the subject, the meter is activated and an exposure reading is made. The photocell reads the light reflected from an angle equal to that of a 50mm lens on a 35mm camera and interprets the exposure requirements for the subject on the basis of the 18 percent neutral standard. When the subject is

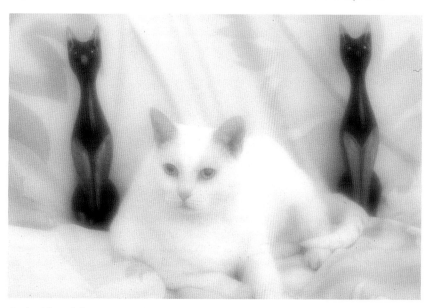

An incident-light meter gave me the exposure I needed for this soft-focus image of my cat. Umbrella electronic-flash lighting was used.

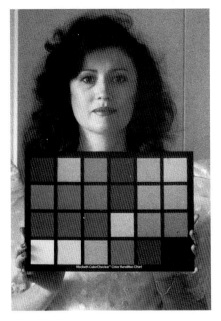

Using a gray scale in a test shot is one way to determine the best exposure for the subject. Here, I used a Macbeth ColorChecker test chart. Although it has just seven steps, its gray scale is easy to read and interpret.

brighter than that, the meter's interpretation is that there is already more than sufficient light for a correct exposure and it shows that less exposure is needed. When the subject is darker, the meter thinks that insufficient light is present and more exposure is indicated. In either case, the resulting image represents a neutral average in color brightness or in gray tonality.

This blind measurement by the meter, however, is likely to be all wrong for the subject, thereby ruining the shot. This can happen in a photograph when the subject reflects too much or too little light, when the surroundings are too bright or too dark, and when there are glaring reflections, hot spots of light, or deep pockets of shadow in an important area around the subject but within the line of sight of the meter. For example, if you were preparing to photograph a person standing in front of a setting sun, a reflected-light averaging meter or your camera's built-in metering system would indicate as "correct" an exposure that leaves the subject a silhouette, lacking detail and texture, against a background saturated with color but also underexposed. This is because the sun is a bright hot spot and the sky may also be bright enough, even with the sun low on the horizon, to cause underexposure when being measured by an averaging reflected-light meter.

As an analogy, imagine staring head-on into a car whose headlights are shining directly into your eyes. Do you see the driver in the dim interior, or do you see only the headlights as you strain to make out any other details? The meter reacts the same way when confronted by very bright light: it sees the light and little else. In sudden darkness, you need several moments to adapt and to discern any detail. The SPD or GPD meter reacts almost immediately, like a cat's pupils, and "opens" up more to allow more light to enter.

In another situation, a meter

indicates that a person standing on a dark street needs much more exposure. But it is actually the surrounding darkness that is skewing the reading. In this shot, the subject appears too light— "washed out."

There are ways to counteract such exposure anomalies, if you do not want these effects. The simplest way is to take a closeup reading of the subject, then tilt the meter away from any bright light source (downward, if the source is the sun or a bright sky). This method assumes that the subject itself is more or less neutral in brightness and tonality. Another way is to point the meter at the palm of your hand—making sure that your hand and the subject are in the same light—and base your exposure on that reading. Keep in mind though, that a clean hand actually reflects more light than a standard 18 percent gray card—about one stop more, varying with skin tone.

"Eyeballing" exposures eventually becomes the practiced photographer's method of choice for dealing with exposure anomalies, especially when he or she works with in-camera metering. The photographer simply judges the scene's brights and darks and estimates how much the meter will be thrown off. The meter averages light levels overall and recommends the basic combination of aperture and shutter-speed, and the photographer adds the correction factor. This factor may be as much as 1½ to 2 stops with extremely bright or dark subjects.

Yet another approach involves the use of the neutral-gray card. For this method to be practical, however, you have to make sure that angle of acceptance of the meter does not include more than the card. With a standard reflected-light meter, position the meter close to the card but without casting a shadow on the card that would block some of the light you want to read. Cameras with telephoto lenses can take such readings safely from a short distance, but the spot meter, with its narrow acceptance angle, works even better.

BRACKETING

Neither in-camera nor hand-held meters are perfect, but you can build a margin of safety into any exposure situation by bracketing. As the name implies, "bracketing" involves both sides of an exposure reading: you give more exposure and then less exposure in addition to, or in lieu of, the exposure recommended by the meter in order to ensure a usable image. The bracketed exposures are usually made in one-third- or one-half-stop increments.

Bracketing does not mean that you have to use up half a roll of film just to get one correct exposure. You can, for example, override the recommendation of your camera or hand-held meter by increasing (or decreasing) the exposure by two-thirds stop and one stop only, if you feel that is all that is called for. You don't have to shoot at the meter-recommended exposure at all, but I suggest that you do so until you get a feel for your camera's exposure system as well as its response to a range of lighting conditions.

There are several approaches to bracketing. You can shoot in the manual mode and bracket by altering either f-stops or shutter speeds. You can bracket in one-half f-stops or in whole stops. You can change shutter speeds in whole-stop increments. You can also operate the camera in the automatic mode and use the exposure-override control, which usually has one-half- or one-third-stop detents (or clicks). Some cameras have only whole-stop adjustment, forcing you to estimate the intermediate positions. If this is the type of camera you have, study the viewfinder display to decide when you have reached an intermediate position. Look for the LED or LCD display to go up or down a notch—the camera's instruction manual will tell you which positions on the display indicate an intermediate step on the shutter-speed scale. (Because LED displays tend to be difficult to read in bright light, though, it is also difficult to accurately determine the exact amount by which you are bracketing. Cameras with digital LCD displays have figures that represent intermediate values.)

If your camera does not have an exposure-compensation control, you can use the film-speed dial. Setting a higher film speed yields less exposure, and adjusting to a lower film speed produces more. This allows one-third-stop increments, which is an improvement over some autoexposure-compensation dials, as well as larger steps. Keep in mind, however, that it is all too easy to forget to return the film-speed dial to the correct setting. The viewfinder display does not tell you that you're actually shooting at a film speed other than that for which the film is rated, and if you forget to return the dial to the correct setting, all subsequent exposures will be "mis-corrected." The autoexposure override, at least, has a viewfinder indication to remind you. But even that can be overlooked at times.

Experience will dictate how much and in what size steps to bracket. Why not bracket every shot? The answer is simple: it's just not practical. "Grab" shots are there for the moment, in most cases, and don't give you the luxury of multiple shooting. Even well-planned shots don't always remain the same through more than one exposure. Besides, do you really want to have only a handful of subjects on one roll of film, with the remainder of the roll filled with identically composed variations on a theme? On the other hand, you may find that several of your brackets gave acceptable exposures that can serve as "original duplicates," saving you from having to make duplicate slides later if the need arises.

I took these photographs in San Juan. I was impressed by the building, the blue sky and clouds, and the trees all around. A TTL exposure produced good color saturation in the sky (top photo), but the foliage lost much of its detail. I bracketed exposures on the plus side in third-stop increments to capture shadow detail. Looking at the slides on a 5000K light box, I found the +⅔ exposure (third photo) to be most suitable for the subject and my feelings about it.

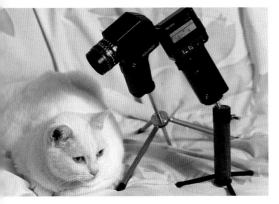

Spot meters literally put you on the spot: these specifically designed reflected-light meters demand diligence in use. Here are two types of spot meters. The larger meter in back has the typical pentaprism configuration; the more compact meter in front not only offers spot metering with available light but also gives you a choice between spot and averaging modes, as well as flash metering in either mode. With practice, you can use a spot meter to read relative densities in a slide, negative, or print, assuming that you use a gray card in the picture.

For the photograph above, I used an incident-light meter to measure the illumination coming in the windows at the left. I made this exposure at 1/30 sec., with the camera in the manual mode and mounted on a tripod.

Spot Meters

These are special reflectance meters that read light from a very tight angle, as narrow as 1 degree—about equivalent to the field of view of a 2000mm lens on a 35mm camera. This enables you to tailor exposures to exact requirements and to reproduce essential details almost without fail.

Spot meters let you pinpoint important subject areas and expose for them. You can point the hand-held meter at a bright highlight or an area of deep shadow, or at anything important to the picture and whose subject detail must be rendered, take a reading, make the adjustments on the camera, and expect a good—even great—exposure.

Spot meters are handy when you photograph distant objects or scenes but especially when you use long-focus lenses. In these situations, typical hand-held averaging meters prove almost useless.

Nevertheless, it is often difficult for the untrained eye to determine in advance where important highlight or shadow detail lies in a distant scene.

It takes practice to become proficient with these meters. For example, you must make a series of exposure readings over a range of brightness and tonalities—or at the very least, the two extremes: at one end, a textured highlight and at the other, a shadow value. Otherwise, you will confront the same types of reflectance problems encountered with averaging reflected-light meters. The alternative is to base your exposure on a midtone, such as that found on a neutral-gray card. This does not mean that highlight- or shadow-biased exposures cannot be made successfully, or that they should not be made, simply that they require care in execution.

Also, a tonal range in color is not quite the same as one in black and white. Some degree of underexposure or overexposure may not be apparent as color distortions, but in a black-and-white image, tonal distortions—whites turning to grays, grays to blacks, blacks to grays, and grays to whites—are much more apparent.

For this reason, photographers who prefer black and white use spot meters more than photographers who work in color do, especially in the studio; there, incident-light meters predominate.

Incident-Light Meters

Unlike reflected-light meters, these devices assess light falling on the subject. A translucent white plastic dome covers the photocell, so that the light falling on it from a full 180-degree arc can be averaged.

In use, you place the meter at the subject's position with the light-collecting dome pointing at the camera. Most incident-light (or more simply "incident") meters have a rotating head for ease of use: its face can be angled toward you, making it easier to read the display without contorting your body or neck.

Like other exposure meters, incident-light meters can be slightly

Incident-light meters are usually held at the subject's position, with the light-collecting dome facing the camera. Many of today's incident-light meters offer both continuous-light- and flash-measurement capability. They may have a swivel head or a sliding dome with an optional swivel head. These meters can read reflected light as well, although an accessory might be required. Others even have accessories that make spot and color-temperature readings possible. Additional capabilities may be built into the meter, especially if it has a microprocessor-based design (as this one does).

inaccurate. Because they read only the incident illumination (that is, whatever light is present), very bright or dark subjects may require compensation in exposure. In general, this does not need more than a half stop less or more for very light-toned or dark-toned subjects, respectively.

Flash Meters

While most photographers get by nicely with automatic flash units, those who use studio flash units or complex lighting setups, even including on-camera flash, require something more in the way of light measurement. Flash meters fill this need. Many are designed to measure all the illumination present or only the flashes of light. Operated as incident-light meters, some can register the light of the flash either with or without a sync cord, whereas others read only in cord mode—with PC cord attached. This difference applies to making exposures in bright light, when the meters record both flash and ambient light in the cord mode, but only the flash in the cordless mode. These meters may also add up several bursts of flash light from a single source for a cumulative measurement.

Gray Card Readings

Because spot meters have a limited field of view, they are the best meters for taking measurements off a neutral-gray card. They can be held at a reasonable distance from the card, thereby preventing any shadows from being cast onto the card.

A reflectance reading of a gray card is essentially an incident reading. Hold the card or set it up at the subject position so that it points about halfway between the camera and the principal light source (in the studio, the key light); generally, the card should be in a vertical position. The light reflected off a neutral-gray card should give you an accurate exposure. However, the few subjects that require an exposure adjustment usually need nothing more than a half-stop less for very bright subject tones and one-half stop more for unusually dark tones. Without these

corrections you may lose essential detail in the highlights or in the shadows.

Exposure Factors

Determining exposure is a fairly straightforward process when you shoot with ambient light or flash, as long as the optical relationships are undisturbed and the light path is unobstructed. While virtually no problem exists with in-camera metering systems with TTL exposure control (off-the-film when using flash), this is not true for other systems, including hand-held meters. An effective loss of light and resulting underexposure can occur when lens extensions are in use—such as teleconverters, extension tubes, or bellows—or even with most forms of filtration, such as color-tinted or neutral-density filters or polarizers. Adjustments are necessary.

A lens-extension factor is simply the number by which you increase the exposure needed to compensate for light lost by extending the lens. This factor must be applied when you use teleconverters as well as when you use extension tubes and bellows to do photomacrography. It is not necessary, however, with simple diopter closeup lenses added in front of whatever lens you are using.

With a lens-extension device in place, the f-number marked on the lens itself is no longer valid; the actual f-stop is smaller. You must calculate the difference in order to compensate for the extension and to expose the film correctly. If the meter in the camera can be used in

The use of a neutral-gray card can be a substitute for an incident-light reading. Direct the card at the light source, and take a reflected-light reading off its surface. Avoid glaring reflections on the card. Bracket on the plus side and experiment with card angles and lighting.

METER CARE

It is critical to remember that exposure meters are sensitive instruments. Meters with galvanometer movements are even more sensitive to shocks than digital meters are, but both types must be protected from any jarring motions—just as you safeguard your camera. Also, you want to keep the meters' light receptors clean, just as you keep

your camera lenses free of dust and grime. Clean the optics on spot meters with great care. For the most part, you need nothing more than a blower-brush, using either the blower or the brush, to remove most particles that find their way to the receptor surfaces or the spot-meter optics. Do not use canned (pressurized) air, except with great care.

available light, take a TTL reading of a uniformly lighted flat surface both with the lens extension in place and without it. Note the difference in terms of f-stops. Use this as the factor of increase, and apply it to the readings from your hand-held meter or flash, whichever the situation calls for. Lens-extension factors are simple to work with in some cases. A $2 \times$ teleconverter requires two stops more, while a $1.4 \times$ or $1.5 \times$ unit necessitates only one stop more.

With filters, the change in the f-stop value comes about more directly: light is blocked when it first enters the lens. The amount of blocking, or a filter factor, is stated on the package by the manufacturer of the filter. It figures in the exposure equation automatically when you place the filter over the lens if you use a TTL system for metering ambient light and TTL OTF for flash. With hand-held reflected-light meters, you can place the filter over the photoelectric cell, making sure that no part of the light receptor is blocked, and take a reading. Some camera metering systems, however, do not give correct readings with plane-polarizing filters. If you have this type of front-lens attachment, make the exposure reading with a circular-polarizing filter on the front of the camera lens instead.

THE SQUINT FACTOR

The squint factor is a way to adjust exposure in order to compensate for excessive brightness. It takes concentrated practice to determine the factors that work best under different conditions with your camera's metering system. Bracketing will help initially. The top picture shows the normal TTL exposure (f/5.6 at 1/1,000 sec.); the shot on the bottom, a moderate squint factor of one-half, giving +½-stop exposure compensation.

Have you ever noticed how, on a very bright day, the sunlight causes you to squint? Of course you have. You also squint when you look at bright sand or snow, or into bright car headlights. How much you squint is directly related to the brightness of whatever you're looking at.

This "squint factor" relates to the way in which a reflected-light meter sees a bright scene. You close your eyelids; the meter tells the camera to give less exposure—and this may result in underexposure, especially with automatic cameras. You have your brain to tell you that the scene was just as bright before you began squinting as it is while you are squinting. An exposure meter, though, whether in the camera or in the hand, does not have that brain to know this; as a result, it determines that there is enough light to give less exposure.

The squint factor helps you overcome this potential problem, which is caused by the meter's interpretation of what it perceives to be correct. The more you are forced to squint and the tighter your eyelids get, the greater the exposure compensation you need on the plus side.

If, for example, you look at a subject in front of a bright sun and you have to close your eyes almost completely to see it, you know to give 1½ to 2 stops additional exposure. Bracket—make extra exposures above and below the setting you think is enough—to be sure that you have at least one good exposure. If, on the other hand, the strain on your eyes is less severe, you would be safe in giving only half a stop more exposure.

Test the system out in order to find correlations that work as precisely as possible. With enough practice, you may not even have to bracket exposures—unless you want to for various exposure effects.

RECIPROCITY-LAW FAILURE

Even well-thought-out pictures can be distorted unexpectedly. There can be an effective loss in film speed and, with color films, an overall shift in values and even in hues. It can happen when you expose a frame of film for a much longer or shorter length of time than the emulsion was designed to handle.

This is known as failure of the law of reciprocity or, more simply, reciprocity failure or the reciprocity effect. While a photographer can overcome the effect to some degree, an exposure meter cannot "see it coming." This effect has not yet been factored into today's computerized exposure meters. We can only hope that a foolproof solution to the problem will be included in future meter designs. For now, correction factors vary with the film in use, as do the effects of reciprocity failure itself.

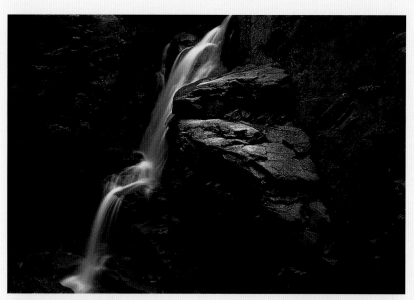

Capturing the milky-white flow of a waterfall requires a shutter speed of 1/4 sec. or longer—enough to cause reciprocity failure. The most detrimental, and obvious, effect is that the water no longer looks white but magenta. You may also notice that the image is a bit underexposed: another consequence of reciprocity failure. On the other hand, the night scene (bottom photo) was a 1 sec. exposure; it shows no detectable reciprocity effect. The distorted colors override the detection of any color shift that may have taken place.

Advanced Flash Techniques

For this studio portrait, I used a self-contained studio electronic flash unit with a silver umbrella. Because there was still a little too much lighting contrast, I asked the model to hold a sheet of white posterboard angled upward. The posterboard served as a reflector, bouncing light back from the flash unit and filling in the shadow side to lower the contrast.

Available light—often referred to as ambient or existing light—is wonderful for making images, but sometimes it can create problems. One solution is to use a simple on-camera flash unit to overcome the available light. But that might not be the best solution. Portable flash used in conjunction with available light or with other flash units is another method. You could add reflector panels or even use studio flash equipment in order to create the lighting effect you want.

Flash-Fill

You may often find that you can expose the background of a picture correctly but that the subject is underexposed because the background is too bright. One way to remedy this situation is to use flash.

Flash-fill is also referred to as fill-flash, fill-in flash, and synchro-sun photography. It is a remedial technique that involves adding just enough light to show detail in shadow areas—portions of the subject that would otherwise be underexposed. It can be used with anything from strong ambient lighting, or simply overly bright backgrounds, to the bounced flash that tends to leave pockets of shadow on the subject, particularly in the eyes. It can also be used subtly, balancing the illumination of important subject areas.

You have to start with a film speed that provides a working range of lens apertures suitable to both the available light and the flash of light that will be added as fill. You might want to use a less sensitive film (slow to medium ISO speed) in order to limit your depth of field. You can, however, if necessary, always use neutral-density filters with a faster film.

Until you get enough practice using flash to fill in the lighting, the process can seem convoluted. But some flash units make the whole thing simpler through either TTL automatic-flash operation or variable power output.

TTL automatic cameras with OTF metering are capable of automatically adding enough light, but you can use any automatic flash unit. First, you have to make sure that the camera's shutter is set to flash-sync speed or to a slower one in order to ensure correct exposure of the background. This may severely limit your choice of *f*-stops.

To take an ambient-light reading with a dedicated system, switch the flash off or use the PC cord, whichever is most practical. You can also use a hand-held meter for the background reading, and leave the flash unit as it is.

For a non-TTL automatic-flash unit, you must first set the film speed on the unit's calculator scale. Next, take an exposure reading of the background, using the flash sync speed (or slower) as your base, and determine the *f*-stop. Set this *f*-stop on the lens. Focus on your subject, then read the distance off the lens barrel. Finally, check the autoflash calculator dial to match up the *f*-stop you are already committed to for the background exposure with the flash-to-subject range, making sure that your subject is within this distance range.

Consider, for example, that your film is ISO 100, your exposure meter indicates a background exposure of *f*/5.6 at 1/60 sec., and your subject is 15 feet away. Check the flash unit's dial to confirm that at *f*/5.6 the output will cover the distance in question. If it will, you have achieved the flash-fill-to-ambient light balance. If the flash won't cover the distance, you'll have a less than balanced lighting effect.

Both the reach of the flash and the fill effect can be controlled by using a neutral-density filter on the lens, a light modifier on the flash, or a flash with a variable-ratio control that operates in the automatic mode. Make sure, however, that the flash unit's autosensor is aimed at the subject correctly; otherwise, it could be exposing for the background.

Flash fill can also be done

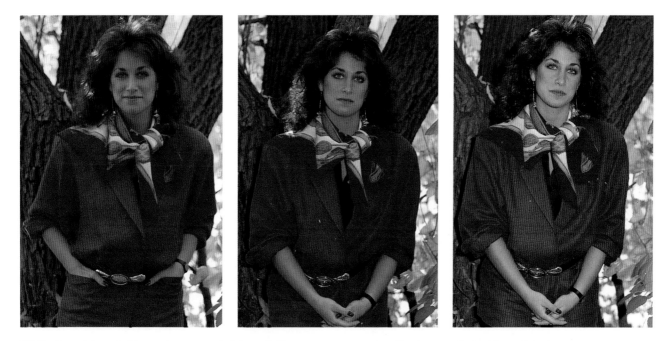

While the subject of this outdoor portrait (photo left) may appear correctly—or at least adequately—exposed, the light filtering through the leaves produces an unnatural color cast. To counter this, I applied flash fill in a somewhat unconventional manner (center photo), not so much to match the background exposure as to correct for subject tones in a way that filtering could not. Manual flash gave me more control. I used a flash diffuser to match the flash-to-subject distance to the needed aperture, and then set the flash output for half power. The combination worked for the subject as well as the background. At full power (photo right), the flash proved overpowering and too harsh.

another way. This is why there are still manual modes in on-camera flash units. Operating the flash in manual gives you more measurable control over the amount of fill light than any automatic mode can. Whether you calculate the amount of flash needed by the distance between the flash and the subject or take a direct reading with a flash meter, the result will be the same.

Here is the basic procedure. First, set the film speed on the flash calculator dial. Take an exposure reading for the background, remembering to preset the shutter at the flash sync speed (or slower). Set the aperture on the lens. Next, determine the flash-to-subject distance. Check to see if the *f*-stop selected allows coverage of the flash-to-subject distance. If the calculator dial shows that the distance lines up with a larger aperture or matches the one based on the exposure reading, you have achieved flash-fill or balanced flash, respectively. If a smaller aperture matches up with that distance, the flash will be too powerful. If this is the case, reduce the unit's output.

Some flash units direct you to move the ratioed-output control until the distance and the desired *f*-stop are fairly matched up. This gives you a balanced lighting equation. To achieve a greater fill ratio, move the control down another notch or two; this reduces flash output even more.

If your flash unit cannot vary its output, block off part of the light with a layer or two of handkerchief. Another approach to reducing the flash output is to use a wide-angle diffusion panel or a neutral-density filter panel designed for the flash unit. You can also remove the flash from the camera and move it back so that it coincides with or exceeds the distance shown on the calculator dial opposite the *f*-stop you are using. This requires a tripod, or an assistant, and a long sync cord.

If you're balancing the light indoors, try bounce flash. A flash meter provides the best indication of the right aperture. It should call for a larger one than that needed for the background: one to two stops are all that is needed to ensure fill ratios of 2:1 and 3:1, respectively.

Multiple Lighting

Through-the-lens automatic-flash systems provide photographers with the ability to hook up several dedicated-flash units (those designed to operate in the TTL mode with this type of camera) for multiple-flash photography by means of a special sync cord. This cord links directly to the camera, like an electrical extension cord plugged into a wall outlet, and accepts several other sync cords that then operate simultaneously with each other. Firing of the camera triggers all the flash units together, and the centralized TTL autoflash control gives the correct amount of light. In this way, your exposures are determined automatically, and all the fuss of trying to calculate the exposure is eliminated.

Another approach to multiple-flash triggering is through "slave" devices. With these, you cannot make use of TTL exposure control but must do time-consuming calculations unless you have a flash meter. If you aren't depending on a TTL autoflash system to begin with

though, you aren't adding to your work.

If you don't use a flash meter, you'll have to balance the light output of the flash units on the basis of their GNs. Set the flash units to the manual mode, and then calculate the flash-to-subject distances. But first, determine the *f*-

All too often, a background reflects the subject's shadow and limits placement of the key light. Adding a background light on a small lightstand eliminates shadows. A reflector did double duty here, serving as both a source of fill light and a blocker of stray light from the background flash. Base your exposure on the key light without the background light, which an incident-light meter may pick up. (Here, it would have added nearly half a stop of light to the exposure.)

stop needed for the unit that will be used as the key light. Place the additional units where needed as fill lights. Unless the lights are equipped with modeling lamps (which on-camera flash units are not), it is difficult to say for certain that they don't overlap. For the moment, assume that any overlap is negligible. Position the secondary flash, with a slave trigger attached for automatic synchronized firing. Do the same for any additional flash units used. If the light from the secondary flash units overlaps with that from the key flash, use a smaller *f*-stop to prevent overexposure. Bracketing is strongly recommended.

If you are serious about multiple-flash photography, consider using a flash meter. It can be used to distinguish lighting ratios between main and fill lights, as well as to determine overall exposure.

With studio lights, the procedure is simpler but at the same time expanded. Modeling lamps allow you to see an effect beforehand. If you wish to modify the light, usually to soften and broaden it, you can add an umbrella-shaped reflector or a light bank; the latter provides soft, windowlike illumination.

If you observe or suspect a strong lighting contrast, you can use a reflector panel to bounce light into shadow areas. Bounce panels can be small or large, depending on the size of the subject and the area to be illuminated. They should, however, be flexible, since they may sometimes need to be bent into shape for the best fill-effect.

Exposure for multiple-light setups is generally based on the key source of illumination. But if you add fill with a reflector and the fill light touches not only the shadow but also the highlight area, make an exposure reading with the reflector in place. This applies to any fill light; otherwise, the highlights may be overexposed. Any added light could be enough to leave its mark. A last-minute exposure reading is a safeguard.

EXPOSURE AND FILM

Films vary in numerous ways. For example, the exposure for one type of film may not be right for other film types. Films are generally classified as color or black and white, fast or slow, and negative or reversal. Reversal color film is also referred to by its end product—as transparency or slide film—it's a "slide" when it is mounted for projection. Color films are also characterized as daylight-balanced or tungsten-balanced.

A color negative film tolerates more overexposure than a color slide (reversal) film does. A faster slide film has a lower tolerance for extremes of brightness than does a slower one. As a result, the slower film allows you to record more detail highlights and deep shadows.

There are other factors to consider when choosing film. The use of filters is different for color film and for black-and-white film, for example. Further, the problems encountered with reciprocity failure are virtually unique to each film. But, fortunately, they are relatively easy to overcome with some types of film when you shoot.

Aside from the most frequently used films, there are several that have special applications, such as instant color and black-and-white slide films, high-contrast films, photomicrography films, and slide-duping films. These may require special handling when you expose them as well as when you process them. With some, you can be more creative. Remember, however, that anything done to excess loses its impact after a while.

No matter which type of film you use, the same principle applies: Each is exposed to conform to a basic equation, whose elements are the film itself, light intensity, and time.

The Exposure Equation

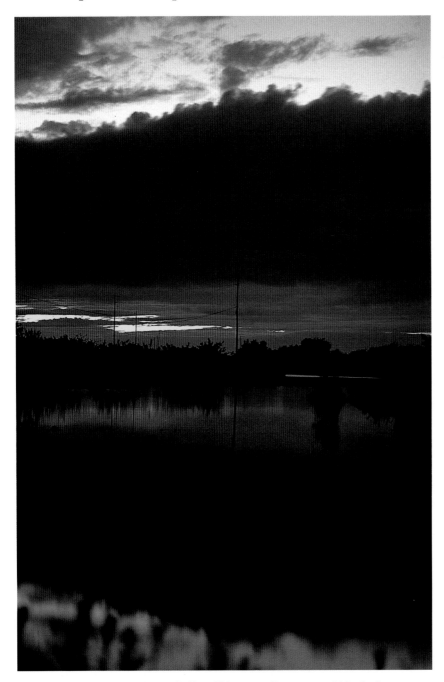

Sometimes an image evokes a feeling. This tranquil scene would be far less effective if it were overexposed.

Exposure is the interrelationship of three factors: the sensitivity to light of the film's emulsion (the layer or combination of layers of light-sensitive chemicals that coat the film base), the intensity of that light, and the length of time the light comes into contact with the emulsion to form what is known as the latent image—the image that exists but remains unseen until it is developed. In equation form, this interrelationship is expressed as $E = I \times T$, where E equals exposure, I equals intensity of light, and T equals duration of time. In actual use, I represents the lens aperture (f-stop), and T is the shutter speed (or, in the case of timed exposure, the length of time the shutter remains open).

Each time you use the exposure equation, you have to balance it. For example, suppose the aperture is f/8 and the shutter speed is 1/125 sec. If you want to close down to f/16 in order to increase depth of field, slow the shutter speed to 1/30 sec. to balance the equation: you decreased the aperture by two stops, and so you needed a two-step increase in shutter speed. Now, however, you may have another problem. Assuming you have a 50mm lens on a 35mm camera, at 1/30 sec. the shutter speed may not be fast enough to prevent camera shake if you don't use a tripod or a flash. If you then raise the shutter speed to 1/60 sec. to ensure a steady hand-held exposure, you must enlarge the aperture to f/11 to balance the equation. This will give you more depth of field than you would get with f/8, although not quite as much as with f/16. But the picture of the main subject will be sharp and unblurred.

Take this one step further. You aren't satisfied with the lens aperture and/or the shutter speed you had to use to get a correct exposure. You want a faster shutter speed and at the same time more depth of field, but you don't want to or can't use flash. Your only viable alternative is to switch to a faster film. (Forget rating the film at another ISO speed for now.)

Film Speed

A film's speed is nothing more than an indication of its sensitivity to light. "Faster" films are more sensitive than "slow" ones. Those terms reflect a film's ability to record an image at fast or slow shutter speeds, respectively, when all other conditions are the same. Keep in mind, though, that fast films are generally grainier than slow ones. As a result, fast films do not usually record fine details as well. But they do have more action-stopping capability. (Negative films, however, are less grainy than reversal films of the same film speed.)

You might choose a fast film because it allows you to use faster shutter speeds and greater depth of field, but the films' increased graininess makes the image look less sharp. It's a trade-off. Your subject, your lens, and your film choice, then, affect exposure, as does the effect you're trying to create. It's all part of developing your personal style.

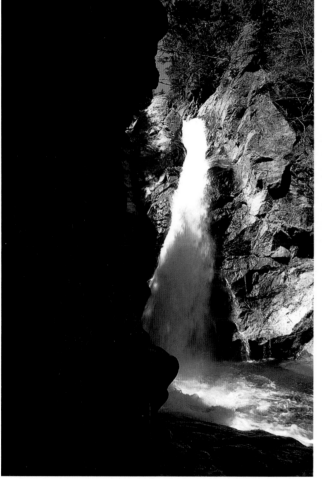

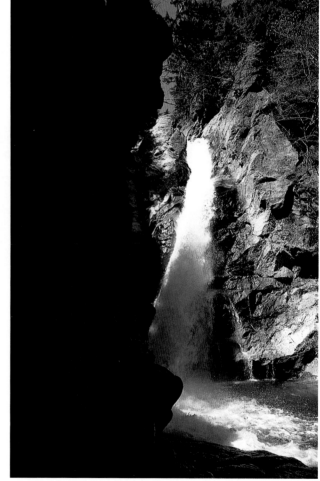

"Slow" films, like the Kodachrome 64 film used for the two pictures on this page, allow you to use slower shutter speeds. And, because lens aperture and shutter speed affect an exposure jointly, an increase in one would seem to require a corresponding decrease in the other. Within the normal range of exposure times, this is true. The only obvious difference between these two shots is the blurring of the water. For the picture above, the exposure was f/5.6 at 1/250 sec.

For the picture above, I compensated for a shift to a smaller f-stop with a comparable shift at a longer shutter speed in order to arrive at an equivalent exposure. The exposure for this shot was f/16 at 1/15-1/30 sec. (The minor discrepancy— the shutter speed here should have been 1/30 sec.—can be explained by a slight displacement of the camera or a small change in light levels.)

ISO

The United States and European systems for rating film speed were standardized by the International Standards Organization—hence the film-speed designation ISO, or more correctly, ISO/°. Many professional photographers still refer to "ASA" out of habit.

At first, ISO film speeds appear strange. They don't seem to follow any logical sequence, going, for example, from 100 to 125 to 160 to 200. But the ISO scale is simply an arithmetical sequence indicating exposure values. The step from 100 to 200 is easy enough to understand since it is a full step away, with 200 being twice as fast as 100. Remembering, however, that 125 and 160 are only one-third of a step apart takes some getting used to. In fact, each step is one-third higher or lower than the next step; the progression 100, 125, 160, and 200, then, shows increments of one third in speed rating. (Some digital exposure meters indicate 120 rather than 125 because, for some reason, the designers found it easier to use a zero as the third digit.) DIN values, now usually represented by the degree symbol (°), follow a logarithmic progression; here, the sequence 21, 22, 23, and 24 represents the same progression as the one above.

Exposure Index

Film speed is the nominal rating given to the film by the manufacturer and is designated by its ISO value. The exposure index (EI) is the film-sensitivity rating the photographer gives to the film in actual use. Usually the two coincide; however, when you rate an entire roll of film at a higher or lower value in order to increase or decrease its light sensitivity, you are establishing your own exposure index. In other words, you can shoot a roll of film rated ISO 100 at EI 100 as recommended, or at EI 400 if you find yourself in a low-light situation.

DX Coding

Many 35mm films have a special area on the cartridge that can be "read" by special contacts in most cameras made today. This encoded film-speed data, also called DX, is transmitted to the camera's microprocessor, which then automatically sets the correct film-speed index. With some cameras, this information is displayed in a digital LCD readout.

DX coding helps photographers who occasionally forget to change ISO settings when they change films. All but the simplest cameras provide for user settings of film speed, though, if you want to override the automatic setting or set a different EI. Don't forget to position the film-speed dial to its DX setting if this is necessary for your camera.

Some films are not DX-coded, and some cameras do not offer DX automatic indexing. Obviously, you have to set film speed manually on a non-DX-reading camera, even if the film itself is DX-coded.

FILM-SPEED EQUIVALENTS		
ISO/°	ASA	DIN
25/15	25	15
32/16	32	16
40/17	40	17
50/18	50	18
64/19	64	19
80/20	80	20
100/21	100	21
125/22	125	22
160/23	160	23
200/24	200	24
250/25	250	25
320/26	320	26
400/27	400	27
500/28	500	28
640/29	640	29
800/30	800	30
1000/31	1000	31
1250/32	1250	32
1600/33	1600	33
2000/34	2000	34
2500/35	2500	35
3200/36	3200	36
4000/37	4000	37
5000/38	5000	38
6400/39	6400	39

STOPS, STEPS, AND EXPOSURE VALUES

Although the terms stop *and* step *are sometimes used interchangeably here, there is a difference between them. A* stop, *is, of course, an f-stop. A* step *can actually be any increment—f-stop (lens aperture), shutter-speed setting, or film-speed value. An exposure value (EV) represents the combination of lens aperture and shutter speed for the given film speed. When you discuss lighting ratios, brightness ranges, or exposure correction, you can use any of*

the three terms: EVs, stops, or steps. For instance, a +1 EV exposure override is the same as a +1-stop increase. Similarly, if there is a two-step or two-stop difference between a highlight exposure reading and a shadow reading, there is a 2-EV difference. Some light meters use a reference scale other than EV, but the increments are the same and translate into the same number of steps or stops.

LENS APERTURE SETTINGS

1.4 1.7* 2.0 2.5* 2.8 3.5* 4.0 4.5* 5.6 6.7* 8.0 9.5* 11 13* 16 19* 22

**Intermediate half-stop positions have different conventional references. For example, f/4.5 is often referred to as f/4½ or f/4-5.6.*

SHUTTER-SPEED SETTINGS

4,000 3,000* 2,000 1,500* 1,000 750* 500 350* 250 180* 125

90* 60 45* 30 20* 15 10* 8 6* 4 3* 2 0"7* 1"

Shutter speeds (all shown as reciprocals except the last two values) are given in half-step increments.
**Values denoted with an asterisk are halfway steps.*

CONTRAST RATIOS

EV DIFFERENCE	CONTRAST RATIO
1	2:1
1.5	3:1
2	4:1
3	8:1
4	16:1
5	32:1

The above figures are useful in assessing the amount of contrast in a scene, either in the brightness range (from a key highlight to a key shadow) or in the lighting ratio (key light to fill light).

Brightness contrast ratios are measured by reflected light, and the range is determined through the use of an averaging or spot reflectance meter. Spot readings are preferable because they define the areas in question more accurately. The lighting ratio,

obtained through the use of an incident-light meter (or a reflectance meter with a neutral-gray card), is an indication of how much fill light is needed (or available) to lighten the shadow side of the subject.

The brightness range is ordinarily used with subjects other than people and outside a studio. The lighting ratio is often important to portraits and other studio subjects. Lighting ratios should usually be kept to 2:1 or 3:1 in order to hold full detail in both highlight and shadow.

Black-and-White Film

Recording a scene in black and white takes more expertise than you might expect. After all, the scene is being reduced to a limited range of "colors." But that is precisely the problem. You won't see in the print the colors that were originally in the scene; instead you will see whites, grays, and blacks. To make matters worse, this range of tones must make the transition from a negative to a print, a process that can reduce detail in even the brightest whites and deepest blacks.

Contrast and Exposure Latitude

There is a direct relationship between film contrast, scene contrast, and exposure latitude. The term "exposure latitude" implies that some variance from a "correct" exposure is tolerable in producing a print that records essential detail in the fullest possible tonal range.

Exposure latitude is limited under high-contrast light but can be extended under low-contrast conditions. In general, the slower a black-and-white film, the higher its inherent contrast. This means that a slow film is less capable of recording fully the tonal range found in a high-contrast scene than is a faster film with its lower contrast. Taking this one step further, a high-contrast film is already limited in the tonal range it can record, and, as a result, recording a high-contrast scene on a high-contrast film offers practically no exposure latitude. The exposure would have to be as precise as possible for the scene to be recorded correctly on a medium-contrast-grade black-and-white paper. This is one reason photojournalists prefer to work with fast films: They want more exposure leeway. On the other hand, architectural or fine-art photographers may prefer to use a high-contrast film and shoot for on-target exposure, then perhaps fine-tune the final image in development and printing.

Exposure latitude also relates directly to a particular film's overall tolerance to exposure error. In general, black-and-white films can tolerate overexposure more than underexposure. Underexposure by even as little as one-half stop can lead to muddy prints, but overexposure by as much as two stops still can be printed readily.

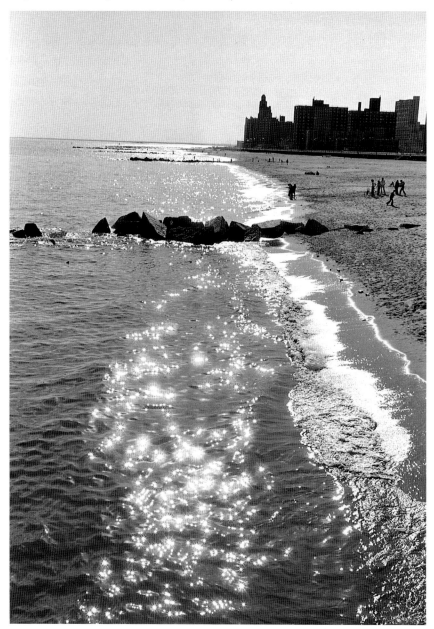

This shot of the beach at Coney Island was not only bright, because of the glaring reflections of the sun in the water, but it was contrasty as well. Stopping down to minimum aperture enabled me to increase the glimmer of the water through starlike specular highlights.

The contact sheet on the right shows all the exposures from one roll of film. If you bracket exposures, you can readily see the results. Even if you don't, you'll be able to better judge which negatives will produce the best prints and, because you see an entire frame, the best way to crop a picture, if at all.

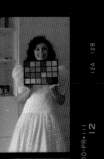

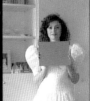
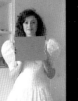

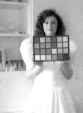

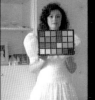
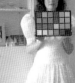

On the surface, these two available-light portraits appear similar, but there is a difference. The hat in the shot on the left does not cast as deep a shadow over the model's eyes as it does in the shot on the right. The left-hand picture, therefore, could tolerate slight underexposure, while the right-hand picture could not—without losing detail in the subject's eyes.

Contrast is a principal element of exposure latitude. In this picture of a rose, important detail in the shadow area would have been lost if less exposure had been used for this high-contrast subject. The opposite is true in this low-contrast scene of a mountain range. Here, haze has reduced the amount of contrast.

Filter Use

Most black-and-white films in use today are panchromatic—sensitive to all colors in the visible spectrum. But they are not sensitive to all wavelengths of light equally. As such, they record different colors with different levels of fidelity. They are most sensitive to blue and least sensitive to red. Consequently, a print made from a panchromatic negative shows blues as lighter and reds as darker than they look to the human eye. Reds may even appear to be nearly black. In addition, panchromatic films are particularly sensitive to short wavelengths at the ultraviolet end of the spectrum. This tends to lighten tones in parts of a scene or in an entire scene, depending on the prevalence of ultraviolet radiation.

Filters affect the color-rendering capability of black-and-white film. Color-tinted filters have a light-subtracting quality. They tend to lighten similarly colored areas and darken areas of complementary color, as seen in the final print made from the negative.

Filters used in black-and-white photography have two functions: some correct distorted tonal relationships and others enhance contrast between adjacent tonal areas, thereby preventing similar tones from merging.

The first kind are called color-correction filters, a term also used by many to refer to filters used in color photography. They are often added to restore flesh tones. In daylight, a medium-yellow filter renders a flesh tone correctly in gray tones; a yellow-green filter serves the same purpose under incandescent ("tungsten") light. These filters neutralize the distortion of skin tones caused even in black-and-white by bluish ambient skylight or yellowish incandescent indoor lighting.

The problem with color-correction filters is that they are not selective: they act upon all colors to some degree, lightening some and darkening others at the same time. In this way, a filter may restore a flesh tone but distort another, equally important, tone.

The red filter that I used here to darken the sky can also be used to lighten a red brick building. There was no chance of an unexpected—and unwanted—change because the blue of the sky was the only color that could be affected by the filter.

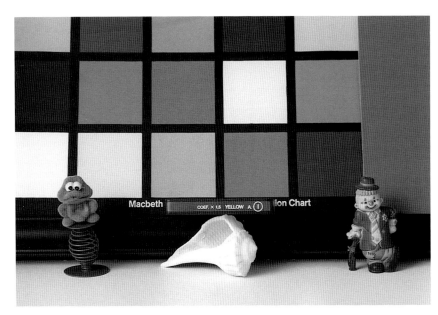

The same problem can occur when you attempt to increase or decrease contrast. You may make one part of a scene look better; but, unless you are careful, you could distort other areas of the scene. Contrast-control filters are commonly used to darken a blue sky in comparison with a lighter foreground. A red filter, for example, will render the sky a deep gray in the print. If your foreground subject is a dark building, however, using a lot of contrast enhancement—such as a deep red filter—could result in subject tones that blend into each other. The solution might be to use a yellow filter to darken the sky mildly or a yellow-green or green filter to increase contrast a little. The yellow might be the safest choice, and using no filter at all might be even better, depending on the situation. In addition, the denser the color of the filter, the greater the contrast effect. A deep red filter, for example, has more effect than a light red one on a blue sky.

In some situations, a color-contrast filter would be unsuitable because of the possible tonal distortions. One such situation is the presence of haze.

Haze—that conglomeration of airborne particulate matter and water vapor—decreases definition in distant scenes. One way to "penetrate" or counteract haze is with a UV or "haze" filter. These filters are nearly colorless, with the faintest yellow tinge. They act upon a key component of haze— ultraviolet radiation—yet do not affect scene colors. Some manufacturers also offer UV filters of heavier densities, for greater haze penetration.

The color patches on the Macbeth ColorChecker chart and the foreground subjects serve as a test target to show the effect of the use of filters to enhance contrast. Only a portion of the chart was necessary to compare filter effects between a medium yellow (top photo) and medium red filter (center photo). Note that subject dyes affect the performance of the filters. Compare these pictures with the unfiltered exposure (bottom photo) and with those found on the color contact sheet on page 47.

FILTERS: HELPFUL OR HARMFUL?

UV and skylight filters are often sold with lenses. They serve as all-around protection for the lens's front glass element when you have to shoot in adverse environments. Even a roomful of smokers is bad for lenses, and filters, which are much less expensive to replace than lenses are, can help protect them.

On the other hand, filters can be harmful, too. Light gets bounced around more and more with each additional air-to-glass (or plastic) interface of filters and lenses. One result is an increased potential for flare, which can lessen definition in the image. Besides, if the filter is not kept clean, not only is the possibility of flare increased, but also definition suffers. Grime and oils from fingerprints can eat away at the coating on a filter, as they can with any lens. This is a serious problem because these coatings are designed to reduce flare and increase light transmission, thereby improving color saturation and tonal fidelity.

When you use filters, you shouldn't combine them. If you must do so, try to keep the combination to no more than two to avoid deleterious effects, or at least use gelatin filters. (Glass and plastic filters are too thick.) Gels, on the other hand, are quite thin. They are easily damaged, however, and must be handled with more care than glass or plastic filters.

Another important point to remember: If you have focused with a filter over the lens of a reflex camera and you remove or change the filter, you must refocus. Otherwise, you might encounter a focusing error, unless depth of field can cover the discrepancy or if the second filter is of exactly the same thickness (not density, but physical thickness) as the first.

The first choice of lens protection should always be a lens shade rather than a filter, but this may not always be practical. If the situation really warrants it, use a UV or skylight filter to protect your expensive lens.

FILTER EFFECTS SEEN ON PRINTS MADE FROM PANCHROMATIC BLACK-AND-WHITE FILM

FILTER COLOR	BLUE	GREEN	YELLOW	RED
Yellow	darkens	lightens	lightens	lightens
Orange	darkens	darkens	lightens	lightens
Red	darkens	darkens	lightens	lightens
Green	darkens	lightens	lightens	darkens
Blue	lightens	darkens	darkens	darkens

These effects are apparent in the black-and-white print. The total effect each filter has on colors in the scene depends on filter density and on purity or depth of the subject's color (its hue or saturation). In some cases, the effect can be reversed, but because the effects are visual, you can observe them readily in the camera's viewfinder.

Color Film: Reversal (Transparency)

Our visual system sees things one way and film sees them another. But they do reach an effective compromise, and that is why we find so many color pictures acceptable. We may not see colors quite the same way the films do, and we have the ability to adjust over a vast range of brightness that often leaves its mark on many films, but we can accept a film's limitations and work within them—which leads to the way we work with color-slide film.

Because color-slide film is, for all intents and purposes, the final product, you have to get its exposure right the first time. After you release the shutter and the latent image is indelibly formed in the film's three-layer emulsion, any attempt at correction is never perfect. This is not true for color negative film, where adjustments are possible in making the color prints.

Color exposure is easily affected by environmental factors—color temperature of the main light source, mixed-source illumination, local color casts (reflections from colored walls, for example, or parts of the subject appearing bluish in shadow), scene contrast, etc.—it is impossible to achieve absolutely correct exposure throughout the image area. What you are in effect doing with any exposure is reaching a compromise you can live with. And luck is with you. You have a forgiving human visual sensory process.

I made this TTL exposure with a 24mm lens. Bracketing on the plus side would have increased the amount of detail in the foreground, but would have weakened the color intensity.

Exposure Latitude

Because color-slide film tolerates underexposure better than overexposure, there has been a tendency to recommend that the film-speed rating be set at a value one-third step higher. Underexposure, when not overdone, tends to increase color saturation and helps prevent washing out of important highlights. (In a slide, lost highlights remain lost.) The problem with this supposedly fail-safe procedure is that it may actually lead to even greater—and incorrect— underexposure if prevailing brightness factors direct the meter to give less exposure. This third of a step can ultimately make a big difference. Consequently, it is better to set the film speed at its rated value, unless your own subjective tests prove otherwise, and simply watch that important highlights are not washed out.

Because slides are viewed by transmitted light, they are more tolerant than color negative film of extreme contrasts in brightness. This doesn't mean that they do not fall victim: excessive contrast can result in the sacrifice of highlight or shadow detail, if not both. Bright days produce a full range of brightnesses and invariably something will be lost in the picture, especially if the exposure is not right on the button. On the other hand, heavily overcast days have a compressed brightness range and, within limits, you can underexpose or overexpose the scene without fear of losing detail in either shadows or highlights.

When shooting a portrait outdoors on a bright day, for example, don't consider the pinpoint, specular reflections in a body of water or the almost featureless pockets of shadow under a log as important parts of the picture. They're not. The person, the subject of your portraits, is what counts.

Yes, exposure latitude, with its limitations, is a reality. But you can still overstep its bounds. When you start to lose more than you bargained for in a high-contrast image, or when your camera

produces images that fail to convey more than just underexposure or overexposure on a low-contrast subject, you have pushed latitude a step too far.

Remember, the important subject areas give you the key to your best exposure.

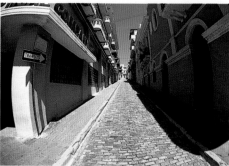

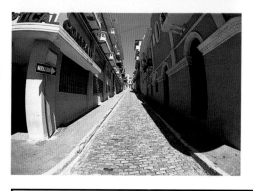

Exposure latitude depends on the amount of contrast in a scene. High contrast generally gives you less leeway in exposure. Even a full stop of underexposure does not seriously affect a uniformly toned subject. But these contrasty street scenes in Old San Juan clearly show the effect of just one-third-stop difference. Shadow detail in the TTL exposure is minimal, requiring an exposure adjustment (top photo). The +⅓ (center photo) and +⅔ (bottom photo) EV exposure overrides helped to improve shadow detail without washing out the highlights.

VIEWING SLIDES

With a color slide, you see the finished picture. If the colors are muddied or washed out, they will look that way no matter how powerful—or weak—the projection bulb or light-table illumination.

All color reversal films are designed to be viewed by projection, for slide or audiovisual presentations, or on

an illumination table, sometimes with publication as an end purpose. The problem is that the source of light may not be correctly balanced for the film being displayed or examined. A slide might look great on a light table, but when slides follow each other in a specified order in a projected slide show, they might look all wrong.

Color Film: Negative

This type of film is more forgiving of overexposure than slide film is and virtually unforgiving of even half a stop in underexposure. As a matter of fact, moderate overexposure—even as much as two full stops—will produce a tighter grain structure. Underexposure will almost guarantee muddy-looking colors.

Exposure Latitude

The popular notion that slight underexposure may benefit color reversal film may not hold true, but a converse maxim—that color negative film should be rated at an exposure index one-third step lower—does apply. Besides contributing to tighter grain, slight overexposure also gives you greater leeway with shadow values in the final print. When shadow values drop out in a negative, they're lost. Giving more exposure at the outset records a little more detail in the important shadow areas.

Tonal Range

Remember that in the end you'll be looking at a print made from a negative, not the negative itself. The print is viewed by reflected light, and the range of tones from light to dark that it exhibits is much narrower than that shown in a light-transmitting slide. A bright, contrasty day that has a full range of highlights and shadows can let you record fairly adequately on a slide film but is far less suitable for a print film. The printing paper simply cannot hold the same brightness range. Consequently, your exposure latitude is lessened. On the other hand, you shouldn't let that stop you from photographing on bright days. What you lose in brightness range is often more than made up for in color intensity.

For the contact sheet on the opposite page, I used different exposures and light sources to show exposure latitude and the effects of the wrong color temperature on a subject, basing the comparison on part of a Macbeth ColorChecker chart. I added a gray card to help test for exposure and color balance with a densitometer (an instrument that measures the density in an image). Densitometer readings showed that the first two exposures, made with studio electronic flash, were correct.

The key ingredients involved in producing the picture below of mating praying mantises were a macro lens, a tripod, an on-camera flash unit—and color negative film. Working with new equipment, Terry Zembowsky and I opted for color negative film to handle possible overexposure resulting from using the flash in a new situation. Using this film had other benefits as well: it provided a negative from which I was able to make a black-and-white print when I needed to.

Color Film: Daylight vs. Tungsten

Most films are balanced for daylight exposure. Loosely speaking, this refers to any outdoor light between sunrise and sunset, when the sky is blue or blue-white. Technically, it means light of a color temperature of 5500 degrees on the Kelvin scale. The 5500K designation includes sunlight and some clouds in a blue sky. The term "daylight" also refers to electronic flash that has been color-balanced to 5500K for daylight film.

Tungsten-balanced film, on the other hand, is intended for exposure by incandescent light sources, principally quartz-halogen studio lights rated at 3200K; but it can even be used with room lights, if you accept some color distortion. Another tungsten film, which is balanced to 3400K, is designed for flood lamps and is used less frequently.

What happens when you expose a daylight-balanced film under tungsten lighting or a tungsten-balanced film under daylight or electronic flash? The colors go *kablooey*. Daylight films go orange or orange-red; tungsten films go blue. But, when this is done with discretion, you get a nice effect.

I used both tungsten-balanced film and daylight-balanced film for these night shots. Tungsten film records the colors in the scene more accurately (top photo) than daylight film, which gives an eerie greenish-yellow cast to the skyline (bottom photo).

In these pictures of a fountain, tungsten film recorded the water as white (bottom photo), while the daylight film has an orange/amber cast (top photo), which I expected.

Filter Use with Color Film

When you take pictures after a snowfall, loose snow can blow in your direction or can drop on you and your equipment. I put a skylight filter on my lens to protect it and to correct for the excessive ultraviolet in the scene. If snow does get on the filter or the lens, whisk it away with a lens brush. If the snow starts to melt, dab it with lens tissue or a clean cotton handkerchief.

Three types of filters can be used with color film: color-conversion, light-balancing, and color-compensating. The first two essentially convert the ambient light to the color temperature the film is balanced for, whereas the third acts selectively upon "offending" colors by neutralizing them. (The filter designations given here, where appropriate, follow the Kodak Wratten system.)

Color-Conversion Filters

When confronted by a situation that would expose a daylight-balanced film to tungsten illumination, or one balanced for tungsten light to daylight or electronic flash, you can convert the light rays entering the lens to the right color temperature by adding a conversion filter.

In the first case, daylight film used indoors with incandescent light records orange-red. This color cast can be corrected with a blue Series 80 filter. An 80A will convert a 3200K tungsten source, and an 80B will convert a 3400K floodlight to 5500K. These are the two most practical filters in this series. Others, available for light sources of 3800K and 4200K, are designated 80C and 80D, respectively.

When a tungsten-balanced film is exposed under daylight or electronic flash, the film takes on a bluish cast that is a little eerie for most tastes. To counteract this, use an amber-colored 85-Series filter. An 85B converts daylight to 3200K, and an 85 filter will produce the corresponding effect under 3400K lights.

These color casts may tempt your creative vision away from the conventional use of color film toward the unconventional. But, as with any departure from the norm, don't overdo it, or it will soon become commonplace.

Light-Balancing Filters

These are designed to convert illumination of other color temperatures to 3200K or 3400K. The 82-Series filters are bluish, to raise color temperature, and the 81-Series filters are yellowish to reduce

Open shade produces a little too much ultraviolet and shortwave blue light, so images can appear too "cool," as in the picture above on the left. Using a skylight filter will remove the bluishness, as it did in the picture directly above, but placing an 81A series filter on the lens, as I did for the shot on the left, will make skin tones warmer. The 81B and 81C filters might add too much warmth—but this depends on the film.

it. Both filter series provide more moderate correction than conversion filters do.

The 81-Series serves another function. Often referred to as "warming" filters, they can deal with excess blue when you are shooting portraits in the shade or under overcast skies, or be used to add warmth. The 81A usually will suffice; 81B or 81C could make the scene or subject appear unnaturally warm (even slightly orangey).

Some photographers use an 81B filter routinely when working with electronic flash. I don't recommend following this procedure without testing the lights to see whether they do need the color correction. A skylight filter or an 81A might be all that's necessary.

Color-Compensating Filters

Certain color effects cannot be corrected adequately with any of the above filters. This is where color-compensating (CC) filters come into play.

Color-compensating filters are available in the primary colors of light—red, green, and blue—and in their complementaries—cyan, magenta, and yellow. Red filters absorb blue and green, green filters act on blue and red, and blue filters subtract red and green light. Similarly, yellow filters absorb blue, magenta filters subtract green, and cyan filters take out red. These filters come in various densities, generally between 0.05 and 0.50, from a number of manufacturers. Each filter is designated by its color and its density. For example, CC05Y is a yellow CC filter with a density of 0.05; it absorbs blue light. A CC20Y, which is denser (0.20), would take out more of the blue.

CC filters are also useful in fine-tuning color balance with studio lights and correcting color discrepancies where reciprocity failure is anticipated. No matter how well an electronic flash unit is color-balanced, there may be discrepancies as the flashtubes age. Corrections like this are necessary only where color is of absolutely critical value, of course.

For precise work, color-temperature meters are available. While there are special correcting filters for fluorescent lights, they are not as precise as the filter combination recommended by such a meter.

You can also use CC filters if you buy film in quantity. If you make a test with one film of the batch and determine that the color balance is off, you can then determine what CC filtration you need for the remainder of films with the same emulsion batch number.

Skylight Filters

Ultraviolet radiation (UV) can add a bluish cast to a color photograph made on daylight-balanced film. It can appear unnatural at times, but not always. Snow scenes sometimes look more natural when they are tinged with blue than when they are pure white. But that same bluish cast may not be as acceptable when a person is in the picture. A skylight filter, usually a very pale pink in color, will reduce the amount of UV reaching the film, and also some shorter-wavelength blue. These filters have virtually no effect on exposure.

You might notice a blue tinge under overcast skies or in the shade, by windowlight, and sometimes even in electronic flash. But the question arises: Should you always correct for the excess UV that's invading the picture? The answer is: Yes and no. Yes, if the resulting color distortion is disturbing. No, don't correct for the excess UV if the color distortion isn't disturbing.

When the subject or scene is partly in sunlight and partly in shade, you have to determine which part of the picture is more important. If it is the sunlit area, leave it alone. If it is the shaded area, you will probably want to use corrective filtration. When skin tones or other readily recognizable colors come into question, it's best—and safest—to add the filter, even if it means giving the sunny side a little extra warmth.

Filter Use with Black-and-White and Color Film

Two groups of filters are equally useful with black-and-white and with color film. These are neutral-density filters and polarizers. Both types affect exposure, but do so differently. However, neither affects the wavelengths—the colors—of the image-forming light rays that they admit.

Polarizing Filters

These filters, often called polarizers, specifically act on all light wavelengths that, as a result of bouncing off reflective surfaces, become polarized—that is, follow a different wave motion.

It's unnecessary to discuss the complex mechanics of light; just keep in mind that a polarizing filter acts on reflected light, reducing glaring reflections and, thereby, deepening tones and colors. It also works on blue skylight, effectively darkening the sky and penetrating haze. The sky-darkening effect is particularly useful with color film, for which any other approach, aside from a neutral-density graduated filter, could also affect other parts of the scene.

The polarizer rotates around a fixed point and is often equipped with a small handle to facilitate rotation. This lets you control the amount of polarized light that will be screened out. An index pointer on the filter mount can help maximize the filter's effect, but a visual check in the viewfinder will prove even more effective.

The sky-darkening effect is directly related to the position of the sun and the blueness of the sky. What's important to remember is that the cleaner the blue of the sky, the greater the effect the polarizer will have. In other words, a haze-shrouded sky will benefit from the polarizer, but only minimally as compared to a clear blue sky. Furthermore, while the polarizer will help separate sky from clouds, it has no effect on a completely overcast sky.

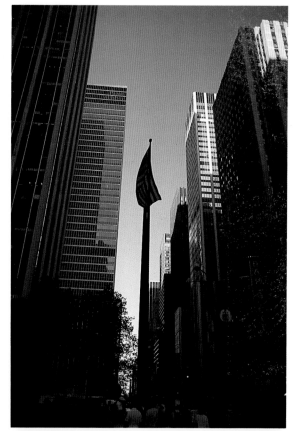

Polarizers do not have to make a marked difference to be effective. Even a subtle darkening of the sky will intensify the contrast, as seen in the shot below. Had I opted simply to underexpose the scene to add depth to the blue sky, I would have underexposed key elements also. Using the polarizer let me preserve shadow detail in the buildings.

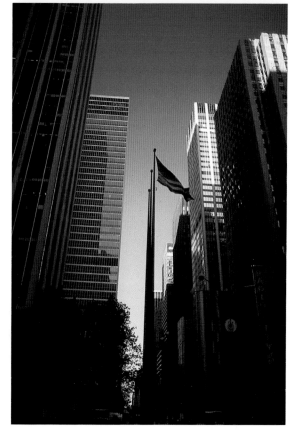

Using a polarizer not only removed the reflections in the water (although not all reflections could be taken out), but also increased the color saturation of the frog (bottom photo). Compare that to the diluted colors in the unpolarized image in the top picture.

Neutral-Density Filters

These colorless filters allow you to slow your film speed or to restrict depth of field by limiting the amount of light entering the lens; they reduce the amount of light by acting uniformly on all wavelengths of visible light. Unlike any of the colored filters, which also reduce the light, neutral-density (ND) filters, as their name suggests, are neutral in their effect on color rendition by the film emulsion.

ND filters come in a variety of strengths (densities), thereby giving you greater control over the effect achieved. Essentially, ND filters are described in one of two ways: by exposure factor or by density. The exposure-factor designation looks something like this: ND2, ND4, ND8. This indicates that you will lose the equivalent of one, two, or three stops when you use them (see the table below). The density approach is perhaps easier to fathom, with values of 0.10, 0.20, and 0.30, representing one-third stop, two-thirds stop, and one full stop of light lost. For example, an ND 0.30 filter blocks one full stop of light.

Because it's almost impossible to have with you the exact density you might need, it's a good idea to carry the ND2 and ND4. If the need arises, you can combine the two. But, as with any filters, you should avoid using more than two ND glass filters together if you can help it, even to increase the effect. If you need something in between, try improvising with the controls on the camera or lens. You can also try a variable-density ND filter to create the desired effect.

FILTER FACTORS

Filter Factor	Open f-stop	or Adjust Shutter Speed
1	—	—
2	1 f-stop	1 step slower
4	2 f-stops	2 steps slower
8	3 f-stops	3 steps slower

For example, if your hand-held exposure meter recommends f/8 at 1/250 sec. and the filter has a filter factor of 2, you can expose at either f/5.6 at 1/250 sec. or at f/8 at 1/125 sec. A filter factor of 1 indicates a negligible effect, although stacking such filters on the lens may affect exposure. Note that filter factors only need to be considered when you use non-TTL exposure readings; cameras with TTL exposure make the adjustments automatically. The same holds true for non-TTL and TTL automatic flash, respectively. These exposure adjustment values also apply to lens extension.

Black-and-White and Color Films: Special Conditions

Sometimes a conventional film won't do for a special situation or can't be used exactly as it was designed to be used. It might not be fast enough or not have enough exposure latitude, or maybe it records only visible light when you need to record the invisible, or perhaps it doesn't produce results fast enough. There are solutions to these problems. Yet the solutions may introduce problems or limitations of their own, including understanding that you have to learn to work within those limitations.

Push- and Pull-Processing

Suppose the only film in your camera bag at the moment is rated at ISO 100. You suddenly see a picture you want, but it needs a long lens and you don't have a tripod, or else the light is too low for hand-held shooting and flash is impractical. You can forget the whole idea of taking the picture—

or you can "push" the film by raising the exposure index (EI) up to give the film more speed. This can turn an ISO 100 film into the equivalent of a 400-speed film, or any speed in between or, with some films, even beyond.

The reverse procedure is also possible. If you find yourself caught up in fast shutter speeds and small apertures, or the brightness of the scene is beyond your meter's capability and you can't or don't want to use a neutral-density filter to lower the film speed, you can "pull" the film-speed rating down to whatever will work. You can, for example, effectively turn an ISO 400 film into one with an EI of 100.

There are two drawbacks, however. First, you have to shoot the entire roll at the newly rated exposure index. For another, the procedure is possible in the first place only with compensatory processing.

"Pushing" and "pulling" of film

actually refer to adjustments made in the processing. In pushing, you have actually underexposed the film. If you are going to get usable images from it, you have to compensate with longer development, varying development times with the number of stops you pushed the film by raising the EI or changing the ISO setting on your camera. The same holds true for pulling film. Pull-processing compensates with shorter development times for film that is actually overexposed.

Some films serve a number of different purposes and can fill in when a conventional film is unsuitable. The chromogenic black-and-white film I used for this image enabled me to shoot with a long telephoto lens from a moving boat, using a shutter speed that was fast enough to prevent blur, without a tripod.

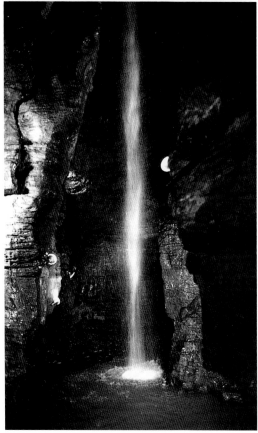

Windy conditions can be a detriment to shooting, even if you're using a sturdy tripod. Shortening the shutter speed will ensure sharper images. However, if the film you're using isn't fast enough, you can push it. For this shot, I pushed an ISO 400 film to EI 800. If you push film too far, though, the consequences will be very noticeable.

Despite the floodlights illuminating this waterfall, the light levels were still low and required an ISO 400 film to be pushed to EI 1600 for this hand-held exposure.

Varying the development times does have side effects. Push-processing increases granularity in the image and adds contrast and, in color films, produces a color shift. Pull-processing reduces contrast and grain, but still can produce a color shift. All these effects are tolerable up to a point, perhaps even desirable, as long as no unnatural-looking flesh tones show up. You can, of course, correct for these color shifts by using CC filters when you take the pictures, provided that you have tested the film in advance and that your processing (your own or a commercial lab's) is consistent from one processing batch to the next.

Chromogenic Black-and-White Film

This film is a fairly rare type that uses emulsion technology similar to that of color-print films to produce monochromatic negatives. It is useful where you expect to meet a wide range of lighting conditions because the same roll of film can be exposed at any setting from ISO 50 to ISO 800. There is no loss in quality at the higher speed, although there is a tighter grain pattern when the exposure is at less than ISO 400. There is no need for compensatory processing unless you push the fast limit. When shooting this film at EI 1600 with low scene contrast, extended development is wise in order to boost tonal contrast.

The film's major drawback is that it is difficult to print from the negatives. Focusing is tricky because the emulsion is thicker than on traditional black-and-white film. In addition, printing must be done on paper designed for printing black-and-white images from color negatives (such as Kodak Panalure)

to record the negative's full tonal range in black and white. Processing can be done in normal C-41 (color negative) chemistry, or, for more exact results, the manufacturers offer special chemicals.

Special-Purpose Films

Sometimes you have to depart from convention to reveal more detail or to record details not seen before. Infrared-recording films are available in color or black and white, as are special emulsions designed for photomicrography. There are also films designed for duplicating color slides.

Infrared films are tricky materials to work with. They record long-wave radiation beyond the visible spectrum. Infrared-sensitive films for both color and black and white distort tones and colors, at least relative to what you might expect, and the results can vary, depending on which filters you use, if any. Black-and-white infrared film must be loaded and unloaded in total darkness, but subdued light is

allowed for color infrared. If you try these, begin with exposure tests or do extensive bracketing to determine the most appropriate film-speed and exposure ratings. Use the instruction sheets that come with the films as a guide. Many processing labs will not even touch these materials, and home-processing can be troublesome. However, people continue to use them for scientific and aerial-reconnaissance work as well as for artistic renderings. But, for many photographers, the novelty wears off after a few of these exposures, as happens with many special effects.

A live subject in low available light often calls for using either a flash unit or a fast film: you never know when a subject will decide to move. Because this frog was in a small glass enclosure, I didn't feel that flash was appropriate—and I already had a chromogenic black-and-white film in my camera. Wanting to see if the claims about the film were true, I pushed this ISO 400-speed film to EI 800, its practical limit, to make this exposure.

Photomicrography color film is a similar case. It, too, requires filtration with most light sources. It is a high-contrast film that has extremely good resolution but a film-speed rating of ISO 16. Like infrared color film, it requires E-4 reversal developing. This can be a problem because most labs are now geared principally for E-6 processing.

On the other hand, color-slide duping films fill a general need. They provide a good color match to the slide films they were designed to duplicate (that is, not every available slide film). In addition, they render the copy image with lower contrast than is possible by duping onto a standard film. However, if the original slide is "flat"—lacking contrast—then you might want to dupe onto a regular reversal film to build up the contrast with little fear of losing shadow or highlight detail.

Instant Slides

There are currently four 35mm format instant slide films, all from Polaroid Corporation: two black and white and two color. All are panchromatic. They come complete with their own processing packs, but a special processor is required.

PolaPan is a continuous-tone black-and-white film rated at ISO 125 for daylight use or electronic flash and ISO 80 for tungsten illumination. PolaGraph produces high-contrast black-and-white images and is rated at ISO 400 for daylight and ISO 320 for tungsten lighting. The color films, both balanced for daylight, are PolaChrome (ISO 40) and High-Contrast PolaChrome (ISO 40). Reciprocity corrections are provided with each package of film. You can process a roll in one or two minutes, depending on the film type and on the ambient temperature. The manual processor (no batteries needed) is surprisingly compact and lightweight, and there is also an AC-motorized version.

The films are obviously not conventional in makeup. They are much thinner, and they are more sensitive to scratching and abrasion than standard films. As such, they require careful handling. Exposures can be in error in cameras using an off-the-film TTL metering system because these read the actual light reflected from the film surface, and these films are shinier than conventional films and so have a different reflectivity. Naturally, this does not apply where light measurement is at the film plane, not off the film itself. Or you can use manual exposure determination or a hand-held meter and make the actual exposure in the manual mode. Finally, because of the nature of these materials, it is better to overexpose than to underexpose them. All these films produce positive transparent images. Filters can be used the same way as with conventional film emulsions, the black-and-white effects being seen as you expect them—only on a slide.

Instant slide material opens up a world of applications. For example, besides creating slide shows, you can test whether a lighting setup works for the subject or whether a camera is operating correctly in a remote location.

Before I exposed an E-6 slide film, I wanted to preview the result, so I used instant PolaChrome ISO 40 film to help me visualize the final image in terms of exposure, lighting, and composition. Because of the medium, the instant slide will be darker than a conventional slide given the same exposure. With that in mind, however, it was easy to see that I would get the results I wanted.

These instant black-and-white slides exposed on Polaroid PolaPan ISO 125 film were intended as the end rather than the means to a follow-up shoot using another film. While a half-stop difference in exposure is noticeable, the film still shows a good tonal range at either exposure.

EXPOSURE FOR EFFECT

When dealing with exposure, don't be preoccupied with precision. A picture doesn't always have to be exposed on the button to be effective. The basic tenets of exposure can be violated—selectively.

Even when you work within the specified exposure guidelines, exposing a piece of film puts many options at your disposal. You encompass the means to create often unique and unusual results with any film and any camera system, simply by the choices you make. The controls on the camera and lens are made to be used not only to create a picture that an exposure meter dictates, but also to bias an exposure to achieve an image that evokes a certain feeling.

Sometimes mistakes become the means to an intriguing photograph. At other times, they make it apparent how important a good technique is to successful picture-taking.

Of course, it's not just the combination of film, camera, and photographer that contributes to effective photographs. The subject has a great deal to do with it. And, there are other factors that play a part. After all, the way light falls on a scene affects the picture, as does the source of that light. To go one step further, you can always achieve special effects through the use of flash, multiple exposure, and a wide range of filters and lens attachments.

Underexposure Effects

Most of the time, erroneous exposures are just that—erroneous. But when the result turns out to be a good image, then it is no longer wrong. Instead, it is the correct exposure to bring out a certain quality or feeling that could not be brought out otherwise. I once photographed a pigeon on the ice. The day was bright, and I unthinkingly allowed the camera's metering system to dictate the exposure. The result was a dramatic silhouette of the bird against a heavily textured sheet of gray-white ice. If I had compensated for the high reflectivity of the ice, the picture would have been just one of a pigeon standing on ice.

Underexposure can be intentional, of course. You can expose a subject for a silhouette. Simply take the meter reading from the bright background only. If the backlighting is strong enough, even a TTL or an averaging reflected-light meter reading a dark subject and the bright background together underexposes the subject sufficiently for it to be silhouetted.

Underexposure can also be used to achieve a low-key effect. "Low key" describes a subdued quality in an image dominated by dark tones and colors. It may work better with some subjects than with others and should not automatically be assumed to impart an emotive force to a picture. The subject must contribute as much, if not more, to that end. Remember, too, that underexposure can result in loss of shadow detail in important parts of the picture, especially under high-contrast lighting.

Strong glare can trick an exposure meter toward severe underexposure, turning the subject into a silhouette, as it did here.

Using a studio flash unit to illuminate the background in the shot on the right, I took an exposure reading of the wall with a spot meter that reads flash and then exposed accordingly for a silhouette. Some spill light is used to rim-light the models. With the light already at minimum output, I had a problem stopping down to the necessary aperture, which was about one to two stops smaller than my lens would allow. The solution turned out to be simple: I moved my models farther away from the light source and metered the wall there.

Overexposure Effects

Because of the predominance of bright-toned areas in the environment, accidental overexposure is less likely to occur than is underexposure. An important exception is when shots are taken at night when the principal subject is surrounded by darkness: reflected-light meters are likely to overcompensate for the prevailing darkness. Another situation favoring overexposure involves a photographer's forgetfulness about resetting the automatic exposure override or changing film speed. This can also happen with exposure compensation with potentially overexposed shots, in which the override goes toward the minus side. Left in place, the override will lead to underexposure. But because there is more likelihood of exposure override to the plus side for bright scenes, and because viewfinder indicators are sometimes ignored or are unavailable, the probability of erring toward overexposure increases.

High-key images can be created simply through a predominance of light tones and bright colors, but you can also achieve this effect with

overexposure. High-key conveys an ethereal quality. To enhance the effect, add some diffusion to the image. A soft-focus lens, or diffusion or fog filter, or any number of means, will do the trick.

High contrast outdoors might not work well if you overexpose a portrait, but adding some soft focus or diffusion gives the portrait on the left a dreamy quality. (Compare this exposure to the photo on the bottom of page 79.)

I bracketed this exposure of La Galeria in San Juan at night for effect. Both the TTL picture and this one (bottom photo), shot at +²/₃ EV, were colorful. The meter-based exposure has more saturated colors, while this picture's colors border on pastels.

Flare Effects

You can consider flare to be overexposure with a difference: the light contributing to the overexposure may only affect a part of the image. Technically it is termed *non-image-forming light*. This means that it does not

You can't always anticipate the exact form flare will take. In this shot of a street in Old San Juan, flare ghosts look like a lens diaphragm opening.

contribute to your exposure. Instead, it veils parts of the picture, if not all of it, in extreme cases.

Flare takes a number of forms. The most common is a "flare spot" or "ghost" of the iris diaphragm (the lens opening). This may be

repeated in a line of diminishing size toward the source of light, which is often the sun. Another form of flare is a radiating stream of rainbow colors. Flare can also veil the entire image uniformly in white light. Whatever form it takes, the effect can often be seen in the viewfinder. Sometimes it can make a picture look more interesting than it would have otherwise, but it can also damage a well-intended image. If you find flare more of a hindrance than a help, shade the lens from the sun or other direct source of bright light or, if possible, shift your position so that the light source is blocked from direct view.

Other potential sources of flare are a dirty lens or any grime on a transparent surface, such as glass you may be shooting through, or a filter. Dust, oils from your fingers, water droplets or any other light-catching residue, scatter light to the point where flare results. The problem becomes acute when light shines onto the glass surface from an oblique angle.

LENS SHADES

These come in a range of shapes and sizes and are made of various materials. They serve more than one purpose. They can protect the front lens element from rain or snow—as long as the wind doesn't blow moisture (or dust or dirt) onto the lens—and can act as a buffer between the lens and anything it might come in contact with. Lens shades also keep stray light from entering the lens, thereby minimizing flare, although there's always a little extraneous light bouncing around that you can't do anything about.

Some lens shades are built onto the front of the lens, but others are separate accessories. When using an accessory lens shade, be careful that it blocks only stray light, not image-

forming light. The wrong size shade can extend out too far and vignette your picture, darkening the corners. Most ultra-wide-angle and fisheye lenses have no effective lens shade because any hood would cause severe vignetting.

Painful experience taught me that even a correctly fitted lens shade can cause vignetting if it is made of rubber and is even just slightly bent out of shape. This can happen with metal shades, as well. The vignetting effect may be so subtle that you won't notice it through the viewfinder. Stop down with the depth-of-field preview to make sure it does not happen. For 24mm to 28mm wide-angle lenses, the depth of the shade is minimal and actually only serves to protect the lens.

As I found out when shooting this New Hampshire scene, a misshapen rubber lens hood can result in vignetting. Stopping down increases depth of field and makes the vignetting more pronounced. So, before you accept a lens hood, make sure that it fits well. Be especially careful with lens hoods for a wide-angle-to-telephoto zoom lens. Use the depth-of-field preview as a check.

Depth of Field

You might not consider depth of field to be an exposure effect. Remember, though, that half the exposure equation involves the intensity of light, which translates into the lens aperture, or f-stop. And this f-stop controls the zone of apparent sharp focus—or depth of field. Depth-of-field effects come in two forms: selective focus and pan-focus.

Selective Focus

This term describes the choice you have in deciding where to place the narrow vertical slice of the three-dimensional world in front of your camera where the lens defines objects sharply—"in focus." You notice this plane of sharp focus most when you shoot at maximum aperture. It can be very dramatic in color film when a colorful background behind the principal point of focus turns into a soft blur. It even works well in black-and-white images, but you have to be more selective with subject/background relationships.

Technically speaking, to get the most selective focus—that is, the shallowest depth of field—you should use your lens's largest aperture. However, certain circumstances permit you to use a smaller aperture, such as closeups at half-life-size to lifesize. Here, depth of field is already severely limited, and the slightest forward or backward movement of the camera or the subject could throw that wafer-thin slice of sharpness into unsharpness. It might put the wrong subject area into the principal plane of focus. A smaller f-stop can help prevent that. Another case in point is ultra-telephoto lenses. Even though the working distances encountered are greater, you will find that focusing at the close-focus limit of the lens severely limits depth of field.

Generally speaking, the degree to which you stop your lens down is governed by the relationship of the foreground and background to your subject, the distance of your subject from the lens, and the focal length of your lens. The farther the subject

When I photographed this scarlet and green leafhopper on a yellow flower (photo above), I wanted to emphasize the insect. With maximum or near-maximum aperture, I was able to get the subject (or a principal part of it) in sharp focus while the background colors blurred softly for a more pleasing composition. Of course, even the slightest movement of the insect, the flower, or the camera, especially at this close range, can throw the subject out of focus as well.

Focusing on the ducks (photo left) for a typical nature shot would have been easy, but I wanted something different. I decided to focus on the branches in the foreground, thereby throwing the ducks completely out of focus. The bright, reflective water helped make the branches stand out.

is from its surroundings, the more leeway you have to stop down because there is less probability that the surroundings will come into sharp focus. On the other hand, greater subject-to-lens distances usually mean that more will be in sharp focus, and you may defeat your purpose. Similarly, using wide-angle lenses almost certainly restricts you to closer working distances and maximum aperture to throw the background out of focus.

Therefore, in order to make selective focus most effective with normal subjects (not in closeup), your best move is to use the maximum aperture on a telephoto lens at the lens's closest focusing distance, with the background deep into the picture. You also must make sure that there is little or no foreground to compete with the principal subject.

Pan-Focus

You rarely see pictures where depth of field extends all the way from front to back, so that everything in them is clearly defined. Pan-focus gives us that image. The term, however, does not apply to images of distant scenes where everything "out there" is in sharp focus by virtue of its distance from the camera. Correctly applied, pan-focus begins almost right in front of the lens and extends all the way out. The obvious way to achieve this effect is to use ultra-wide-angle lenses, stopping down to the smallest aperture as added insurance. A fisheye lens unquestionably will do it. But you need not be limited to extremely short focal lengths.

Most lenses have a depth-of-field scale engraved on the barrel. This scale has *f*-stop indicators that mirror each other on either side of the focus mark. When one of these indicators is set to the infinity position, its identical indicator on the other side shows you the nearest point to the lens that will be seen as acceptably sharp; you will have sharpness from that point to infinity. Here, you can clearly see that the smallest aperture maximizes depth of field.

You can also follow this procedure for points short of infinity when you want to use pan-focus. But as you focus closer, the range of distances that will appear sharp diminishes considerably.

The simplest way to achieve maximum depth of field is to use a wide-angle lens. Stopping down increases depth of field even more. For this shot of a shopping mall in Coconut Grove, Florida, I used a 24mm perspective-control lens for an aperture-priority exposure, and stopped down to f/8.

Freezing Movement

When you work in ambient light, the key ingredient to stopping motion is a relatively fast shutter speed. The watchword here is "relatively." With focal-plane shutters, the speed of the shutter curtain movement is relative to the rate and direction of movement of your subject. There are several rules that can help you determine just how fast to set the shutter. If your camera is set to aperture-priority automation, adjust the aperture to ensure a fast enough shutter speed. You may find it preferable to put the camera into the shutter-priority or high-speed-program mode, or in manual. The first rule is: The faster the subject's rate of motion, the faster the shutter speed has to be. Next, the farther the subject is from the camera, the slower the shutter speed can be—within reason—to freeze the action. The third rule: A subject moving parallel to the film plane of the camera needs a much faster shutter speed to freeze its movement than does a subject moving toward or away from the camera. The closer the relative positions are to a right angle, the slower the shutter speed can be.

The fourth rule says that a subject viewed through a telephoto lens appears to be moving faster than one viewed through a normal or a wide-angle lens. You can, therefore, use a faster shutter speed with a long lens than with a lens of shorter focal length. Finally, the fifth rule that will enable you to avoid blur when hand-holding a camera: Use a shutter speed whose reciprocal is at least the same number as the focal length of the lens. With longer telephoto lenses, it pays to go one step faster—for example, 1/1,000 sec. for a 500mm lens. In the medium focal-length range, for instance, from around 85mm to 135mm, you might be able to get away with a slower shutter speed if the lens is on the heavy side (faster lenses usually are). With wide-angle lenses, you may be successful with a shutter speed that is one step slower, but it's doubtful that you'll freeze the subject's motion with this shutter speed.

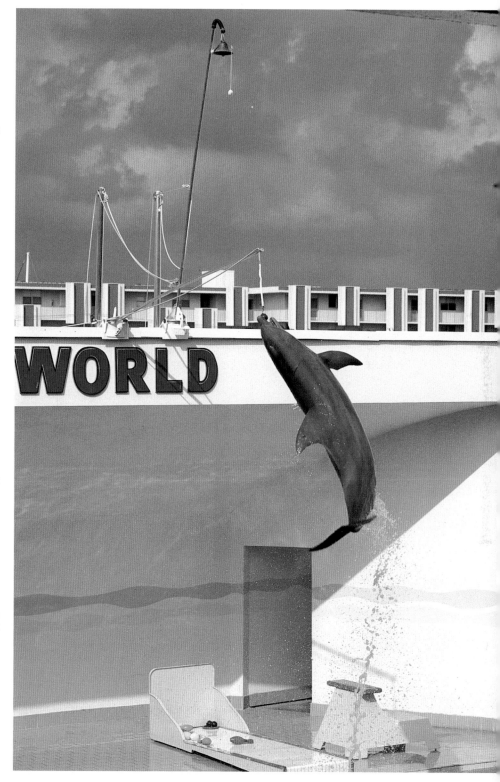

Although a fast shutter speed was not needed here, it helped freeze and capture the moment. The water droplets enhance the effect. I made this f/8 aperture-priority exposure with a 90mm lens at +⅔ EV to compensate for background brightness. The shutter speed of 1/125 sec. may not be considered fast, but at this distance it worked well.

When Movement Almost Ceases

When a dancer leaps into the air, there is a moment—the "dead point"—when motion actually appears to stop. That moment occurs when movement begins to go in the opposite direction; in the dancer's case, from leaping to the highest point to beginning the descent. For that instant, fast shutter speeds are unnecessary, and a shutter speed of 1/60 sec. will most likely capture the moment with little or no blur.

The only problem to watch out for is the direction of return. If, for example, the dancer is making a leap that follows an arc across your angle of view, you need a much faster shutter speed (remember that the subject is moving parallel to the film plane of the camera). If, on the other hand, the leap has a good deal of verticality to it, you stand a good chance of virtually freezing that movement at that 1/60 sec. shutter speed.

It took considerable diligence and several exposures to get this shot of a hornbill in flight just right, but I succeeded—with minimal blur. Here, the bird's expansive wings had reached the dead point, *a moment of relative stillness before returning to the uplift position.*

CONTROLLING MOTION

Relative Subject Distance	Recommended Shutter Speed	Direction of Movement Relative to Camera Plane
Distant	2/Focal Length	Perpendicular
Medium distant	1/Focal Length	Diagonal
Relatively close	1/(2 × Focal Length)	Horizontal (also windy conditions)

To use this chart, match up the relative subject distance with the direction of movement. To freeze motion for a distant subject moving perpendicular to the camera plane, use a shutter speed equal to half the focal length of the lens. For a 100mm lens, that would round off to 1/60 sec. On the other hand, for a relatively close subject moving in the same direction, you need 1/125 sec. with the same lens. Note that this chart applies to subjects moving at moderate speed relative to you. An airplane may be seen as moving more slowly across your field of vision than a bus that is closer but still at a considerable distance from the camera. A tripod may be necessary for relatively slow shutter speeds. When in doubt, use the faster shutter speed.

CAPTURING THE CRITICAL MOMENT

It's often easy to miss an important moment. If you release the shutter too late or use an unnecessarily slow shutter speed, you will either miss the moment entirely or blur it.

There are several steps to capturing the critical moment. First, you have to recognize the moment. It might not require split-second timing, but it does require you to be alert and responsive. If you suspect that something important is about to happen, prefocus the lens, check the shutter speed and lens aperture to make sure that they match the action and the desired depth of field, and, of course, make sure that you have enough film in the camera to make at least one exposure. If you think that you will want to get off several shots but find that there are only one or two frames left—and you're sure you have enough time—rewind the film and load a fresh roll. Switching to a second camera already loaded is a better option.

Next, squeeze gently on the shutter with the lens trained on the spot where the action will break or where the subject is headed. You can try panning, but this might cause you to jam the shutter release and blur the picture or, at the very least, to tilt the camera and ruin a carefully planned composition. If you want to pan, keep your "free" eye open. In any case, don't wait until a fast-moving subject has reached the point of focus: it will be too late to release the shutter. However, you can release the shutter as soon as the subject breaks into your frame of view if it is moving relatively quickly and is traveling a short distance. If the action of the critical moment is repeated, release the shutter as soon as the action begins. You might have to rely on trial and error, but if you make several exposures, at least one should be on target.

Finally, don't rely on a motor drive. It is a great advantage, but no conventional motor drive can operate at speeds so fast that a critical moment between exposures won't be missed. Release the shutter one exposure at a time. Coordinate your eye and hand, and make the one exposure that counts.

For the shot above, I released the shutter the instant the trainer flicked his wrist to toss the fish into the sea lion's mouth. Because of the movement of the fish and my use of a 300mm lens, I had to shoot at a fast shutter speed. The initial aperture-priority exposure read f/16 at 1/1,000 sec., and I gave this exposure a +2/3 EV override because of the bright background.

You can't always anticipate when something unusual—and worth shooting—will happen. This sailboat (photo right) seemed to fish the blimp out of the sky. The compression effect was enhanced by a 300mm lens.

Blur

Intentional blurring of a subject can result from either using a slow shutter speed when the camera is held still while the subject moves, using a slow shutter speed while the camera is moved parallel with the subject and at the same rate of speed—a technique called *panning*, or jiggling the camera on purpose.

For a stationary camera, you simply mount the camera on a tripod or other firm support and select a shutter speed of 1/30 sec. or slower (although some subjects blur at 1/125 sec.) With this technique, any part of the subject that is in motion will be blurred unless it is ultra-slow. The faster the subject motion and the slower the

shutter speed, the greater the degree of blur.

For a moving camera, the shutter speed can range from 1/30 sec. to 1/125 sec. and still be effective. Here, begin by following the subject's movement at either end of the picture field, then gently squeeze the shutter release while you pivot on an axis, following the subject with the camera all the while the shutter remains open and then some, just to prevent any jarring motion of your own from affecting the image. In this method, a good part of the subject remains sharp and unblurred; it's the background that becomes a total blur.

Both blur techniques can be used at any time. If there's too much light to permit the use of slow shutter speeds, add a neutral-density filter dense enough to let you use the necessary slow shutter speeds. If you haven't already loaded the camera, all the better. Put in a film with an ISO rating that is slow, relative to the lens focal length, subject motion, and prevailing level of light.

But what if you just happen to have the wrong film in or the wrong lens mounted on the camera, and the light is too low for anything but a blurred picture? In this case, it pays to experiment. (Your only other alternatives are to switch the film or lenses midstream, or not to take any pictures at all.) Possibly the best approach here is to pan. Panning lets you keep a good part of the subject sharp, despite some blurring of the subject and considerable background blur.

Intentional blur can also occur when you jiggle the camera. While the results are less predictable than with other blur techniques, you can come out with interesting pictures after a while. Don't go overboard with this approach, though.

The last approach to blur is called the *oops factor* for "Oops, the camera moved." It occurs when you either jam down on the shutter release or when you just don't hold steady. But this shaky exposure can turn into a nice picture.

A speeding car? No. In this case, panning with the vehicle's movement blurs it as well as the background and enhances the sense of motion. The streaked highlights add to the effect.

Using a relatively slow shutter speed and keeping the camera still while the subject moves will almost certainly guarantee a blurred picture. This picture, shot at 1/125 sec., is partly blurred, because the two coati were playing fairly close to the camera. Even this shutter speed was not enough to freeze the movement of the one scampering up the tree limb.

Timed Exposures

Some of the most exciting exposure effects come about by using shutter speeds of one second or longer. The camera should be mounted on a good, solid support or any movement will introduce another type of blur—unwanted.

When you go beyond the shutter speeds marked off on your camera's shutter-speed dial, you have to count off the seconds. All you need is a watch with a second hand or a digital readout in seconds, or a good sense of timing. Practice pacing yourself and counting "one–one thousand, two–one thousand," checking yourself against the second hand on your watch, and you'll soon be ready to time exposures in the dark. You'll have to switch to the manual mode

on the camera: automatic operation is too unreliable. A countdown timer that gives an audible signal will come in handy, letting you relax and enjoy the view.

Don't worry about pinpoint accuracy, with most time exposures, you have some leeway. For example, I timed my fireworks exposures from 1 sec. to 5 sec. and achieved good results in all cases, as long as there were enough fireworks in the patch of the sky where the lens was pointed. Star trails, on the other hand, require counting time in hours. They may keep you up half the night, as you bracket not by *f*-stops but by minutes and hours to achieve the most dramatic result—meanwhile hoping that the night stays clear all that time.

Fireworks are fun to photograph. Try to find a spot away from the crowd. Mount your camera on a tripod, and use a locking cable release. Use a slow to medium-speed film with the camera in the manual mode, and keep the shutter on "B" (Bulb) for one to three seconds. The time variable is necessary because you can't tell beforehand how many bursts there will be and how quickly they will come. Start at f/5.6, and move toward minimum aperture to vary the effect. The focal length of the lens will depend on the distance between you and the fireworks.

Flash Effects

The high speeds that today's flash units achieve can help you capture some unusual moments. While an electronic flash might freeze a moment in time in 1/20,000 sec., a flash exposure does not necessarily replace an ambient-light exposure when it comes to subjects outside the flash unit's range. You have to keep that in mind. The flash can only be an effective tool when it is used within its own confines. But even there a wide latitude exists.

Using Light Falloff
By using a small aperture, you are effectively limiting the distance the electronic flash unit will throw its light (see page 85). As long as there is insufficient ambient light to illuminate the background, and there are no background lights or reflective surfaces to act as catch lights, you can limit your image to the main subject. The inverse-square law states that the intensity of light falls off in direct proportion to the square of the distance from the source. Taking advantage of this is one way to get rid of distracting backgrounds.

Freezing and Blurring Motion
Electronic flash can freeze motion, but a combination electronic flash/ambient-light exposure can be used to add an element of blur that gives the image more dynamism. All that's necessary is enough ambient light for the non-flash exposure. Remember that the flash-sync speed is predetermined, so that you cannot use a faster shutter speed. But you don't want to. You want to choose a slower shutter speed, so as to record the blurred ambient-light image.

When this blurring technique is applied, the subject usually appears to be moving backward because the camera makes the sharply defined flash exposure first, followed by the ambient light blurring, on the same frame of film. To overcome this drawback, the system must offer delayed-synchronization flash firing, or second-curtain flash synchronization. Second-curtain sync, which is applicable to focal-plane shutter cameras (and at least one camera has been designed with this feature), fires the flash right before the second curtain begins running. As a result, the blurred image trails behind the sharp one frozen by the flash. In this way, for example, a cat jumping forward won't look as if it's jumping backward.

This technique might not work with some dedicated camera/flash systems. Check the instruction manual to determine whether your camera has a manual override, either with a manual flash mode on the camera or through the use of a standard PC cord.

Flash directed straight at a subject in the distance will exhibit properties of the inverse-square law, which states that light falls off proportionally with the square of the distance from the light source. Foreground areas will turn out too bright and may be washed out, whereas background areas will darken into oblivion. However, light falloff can be used effectively to show depth, as it does in this shot of a cavern.

The speed of the pottery wheel, the indoor light, and a 180mm lens all dictated the use of a flash unit to freeze movement. The flash-to-subject distance for this TTL exposure required a lens aperture of f/2.8 for the compact on-camera flash I had.

Filter Effects with Ambient Light

The same filters that are used to correct for tonal and color distortions can be used with color film to *distort* color. In addition, numerous filters will darken or color parts of the scene, gradually fading to clear plastic or glass so that the rest of the picture remains as it is. There are also front-lens attachments that cannot really be called filters, (although many people refer to them that way) because they do not screen out or tint the light but distort it. Filter effects can be hard to resist, but they can be overdone.

Color-Filter Effects
It is tempting to throw in some color, especially when there is a filter already built into the lens, as in some ultra-wide-angle lenses and most fisheyes. Somewhere in a remote corner of your camera bag there lies a colored filter that you've been saving for contrast enhancement with your next roll of black-and-white cloudscapes. You might also consider using special bicolor filters that, with either a built-in polarizer or a separate polarizer, can change color when you simply rotate the polarizer's mount.

The main problem you might encounter with any of these filters is using them with a hand-held meter: you may be overzealous and forget to apply the filter factor. Another potential problem is using a combination polarizer/color-blend filter with a TTL-reading camera

When I set out to photograph New York's Verrazano-Narrows Bridge, I didn't expect an opportunity to create a simulated moonscape. But when the sun ducked behind the clouds for a brief moment, I put a blue filter on my 28mm lens and allowed the sky to underexpose the image.

requiring a circular polarizer. This results in exposure error. You might do best using a hand-held reflected light meter and placing the filters, correctly oriented, over the receptor cell of the meter to get a more direct reading, then using the camera in manual operation with the exposure data obtained from the meter. (Just don't forget to put the filters back on the lens.)

You can go one step further with

any colored filter that you use for effect. By varying exposure up or down, you either lower or increase the filter's density effect.

You can use a filter to simulate a full moon on a cloudy night by photographing the sun behind clouds with a blue filter. Bracket for effect, but allow the sun to underexpose the image. To experiment further, use different densities of blue. Be careful not to have the sun showing, as it will stand out much brighter than its surrounding and diminish the effect.

Graduated-Filter Effects

As their name implies, these filters have a graded density, heaviest at the top and generally clear at the bottom—or vice versa, if you invert them. Graduated filters are generally used to tone down an excessively bright portion of a picture, usually the sky. To do that without adding any color, use a graduated neutral-density filter. Other filters, such as tan, orange, or pink, tint the sky odd colors. Exposures for these filters are best made with the camera's own metering system.

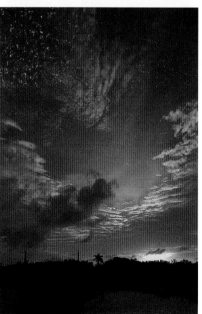

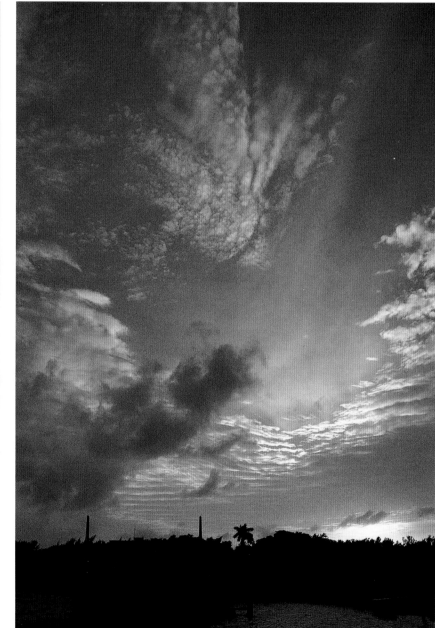

Cloudy conditions prevailed during a recent trip to Florida, but these clouds were ideal (large photo). Ordinarily I would not have opted for color filters, but because they are part of my 24mm perspective-control lens, I decided to try the yellow (top photo) and orange (bottom photo) filter positions. I used the TTL exposure for the sky and clouds and left the foreground slightly underexposed. Exposing for it would have diminished the color intensity and the contrast between the sky and the clouds.

Special Filter Effects

Some of the most popular and enduring filters include diffusion, fog, and mist-effect filters, which simulate these conditions. All of them spread the highlights into shadow areas, but, unlike real fog or mist, there is no tricky meter reading to contend with. Watch for flared-out highlights with these filters.

Then there are diffraction filters, which break light up into its spectral (rainbow) constituents. They and star filters act upon point sources of light. With the diffraction screens, your only concern is the effect of these point sources on your exposure. With star filters, however, the light flares out and can affect exposure. A combination of the point sources and flaring can lead to underexposure. Start by shooting at the metered exposure, and then open up by one-third or one-half stop, or more, depending on the severity of the flaring effect and the intensity of the light sources.

There are a number of lens attachments that repeat a part of the image. Some do this in a circular array; others parallel to the original image. These can cause exposure problems when the part of the picture that is repeated is either quite dark or quite light, because the result will be a greater portion of the final picture's being occupied by that influential dark or bright image element.

I happened to have several special-effects filters with me on a recent trip to New Hampshire. While hiking, I came upon this spot and thought that I would try to make the pristine beauty a little eerie. I combined a bicolor filter, a polarizer, and a mist-effect filter for this shot. Suspecting underexposure from the brightness of the sky as well as the specular highlights in the water, I bracketed the exposure on the plus side.

Filter Effects with Flash

Unlike ambient-light exposures made with filters, for which it's practically impossible to put a filter directly on a light source, you can put a filter on one or more electronic flash heads. Many subjects may appear drab and lifeless, no matter how well they are lighted. The problem is that they lack color. When you use filters and flash, you can selectively color parts of a subject or scene by using filters on the flash, instead of on the lens. Dull, inanimate subjects seemingly spring to life.

Studio electronic flash uses special colored gels, but you don't need a large flash unit to add a little color to your subject. Many portable units offer accessory filter systems, which may include wide-angle and telephoto panels to broaden and extend the reach of the flash light. If accessory filters are not available, you can use gaffer's tape or rubber bands to secure any colored acetate over the flash head.

The only problem with these portable systems is that, unlike a studio flash, they do not have modeling lights to let you see in advance exactly what the effect will be. Use a flash meter, if possible, to measure exposure, or use a camera with TTL-autoflash capability.

Wanting to make this white minicassette recorder appear more interesting, I added some props and color. I used a twin-flash system mounted on the front of the lens and added a red filter to one flash head and a blue filter to the other. One drawback to this approach: without modeling lights, it was impossible to visualize in advance what the effect of the filters would be.

Multiple-Exposure Effects

These can lead to some interesting and enjoyable results. Of course, not every subject or scene lends itself to this. For example, superimposing two busy scenes on the same frame of film would not work well. You can obtain the best results by keeping at least one of the exposures simple and uncluttered, free of unwanted details that might be difficult to "read" when in the completed image. Most cameras today have some provision for making double exposures, or some suggestion about this in the owner's manual.

Nonoverlapping Exposure Effects
The easiest approach is to record two separate images on a single frame but to keep them from overlapping. In this way, each exposure is made as if it were on a separate frame of film. In order to do this, you need a background that is either black or totally unilluminated. If you light your subject with flash, position the flash unit so that it neither casts shadows on the background nor allows light to spill over onto the background. Lighting the subject from the back and to one side, with a reflector adding fill-light on the shadow side of the subject, will work well.

Plan the shot in advance, so you know where each subject will be positioned in relation to the other. Slight overlap is no problem; there will be some overexposure in the overlapping areas, but it shouldn't prove objectionable.

Effects of Overlapping and Overexposure
The simplest and most direct approach, with regard to composition, is to expose two images on a single frame of film in such a way that they overlap fully. Here, you are, in effect, doubling the exposure. Sometimes this overexposure works, but it's generally not the best way.

A better approach is to halve the exposure for each shot. If you take three or more exposures and superimpose one right onto the other, divide your total desired exposure by the number of shots you plan to superimpose to arrive at the optimal exposure for each one. Then bracket one of the exposures by plus and by minus a half-stop, for insurance.

Stroboscopic Effects
Some portable flash units offer stroboscopic capability: they can put out several short bursts in quick succession. These effects are applied to moving subjects. The end result is not unlike the results you got by superimposing images onto a single frame of film. Here, however, the intention is to show movement, and many exposures are made. Stroboscopic photography requires a completely darkened room, preferably with a black background, and a subject that is moving in one direction. Slight overlap may be acceptable—and sometimes enhances the feeling of the subject's motion.

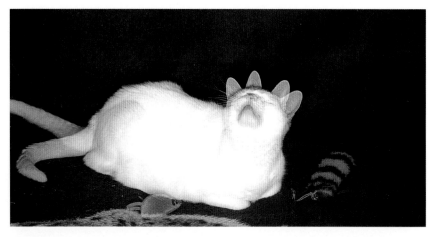

This double exposure was made with a Dale Beam, distributed by Protech Instruments. Using a darkened room and a dark backdrop, I placed the beam at the camera position and put a flash unit on top of it. With the camera on "B" (Bulb), I tossed one of the cat's toys in order to break the beam, which then triggered the electronic flash unit.

I wanted to give this a ghostly air, so I held an old 35mm rangefinder camera and added a sepia filter to enhance the effect. Then, to blend the character into the image, I made a double exposure.

THE "OOPS" EXPOSURE FILE

These exposure errors consist of actual mistakes that I made. Most often, the error is clearly a mistake; others might be hard to see without a good magnifying loupe. And at least one error resulted in an interesting image that I would not have thought to make at the time.

Exposure errors often come about because you concentrate too hard on your subject, shoot under pressure, or focus on extraneous details surrounding you, such as a horde of people or rather intimidating creatures. As a result, you tend to overlook last-minute checks to see that all the controls are set, and set correctly, or that there is even film in the camera.

You learn from each mistake. As a reminder, keep your own "oops" file and refer to it occasionally.

There are a number of ways you can make an exposure error. Setting the film speed incorrectly on the camera is one. Setting the camera in the manual mode and thinking that you're shooting in the automatic mode is another. You can also make an exposure error by setting the autoexposure override in place and then forgetting to reset it to its zero position. One of my cameras has no viewfinder indication of this, but even with those cameras that do, you may forget to take the viewfinder indicators into account in the heat of the moment. This photograph is the result of an erroneous +1 setting on the exposure compensation dial.

Believe it or not, this is a view of a harbor at night in Saint Thomas. The exposure took longer than expected and, not paying attention, I picked up the camera and tripod. I heard a click and realized the shutter had been open all along. This blurred image is the result.

Here, I apparently moved my camera just the slightest bit when recocking the shutter in what was intended to be a double exposure of my making progress down a hiking trail. I look as if I were caught in the middle of a mild earthquake.

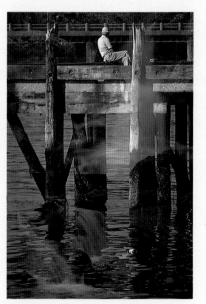

When you take a roll of film out of your camera before using all the exposures, fully intending to use it at a later date but forgetting to mark down where you left off, you usually end up double-exposing some frames. This is what happened here.

Sometimes it is very difficult to determine where the fault lies, whether it's a focusing error or motion blur. In this shot of a parrot, the beak is in focus while the eye, which should be the principal point of focus, is not.

This picture shows a streaked effect, the result of motion blur. A good 8X or 10X loupe can help you pinpoint the problem.

Part Four

EXPOSURE FOR SUBJECT

Exposure control is more than just knowing which combination of *f*-stops and shutter speeds to set, or how to use the camera's exposure metering system or a hand-held meter. While certain techniques may apply to several groups of subjects, in the end each subject you photograph requires individual treatment. This is not simply in the way you approach each one. The control you exercise in bringing out the essential characteristics—the life—in your subject rests largely with the exposure. The only common element many subjects have is you, the photographer.

Remember, no matter how many times you have photographed one subject, it is never quite the same. Something has changed: either the subject, or you, or the way you see the subject and expose for it.

Beyond that, even the camera should be treated with a certain sense of novelty, with you in control, knowing that as you point the camera or the hand-held meter a little down or up, or a little more to this side or that, the exposure system might respond differently. You have to know to what degree, if any, those deviations may prove beneficial or detrimental to achieving the image you envision.

Portraits: People Outdoors

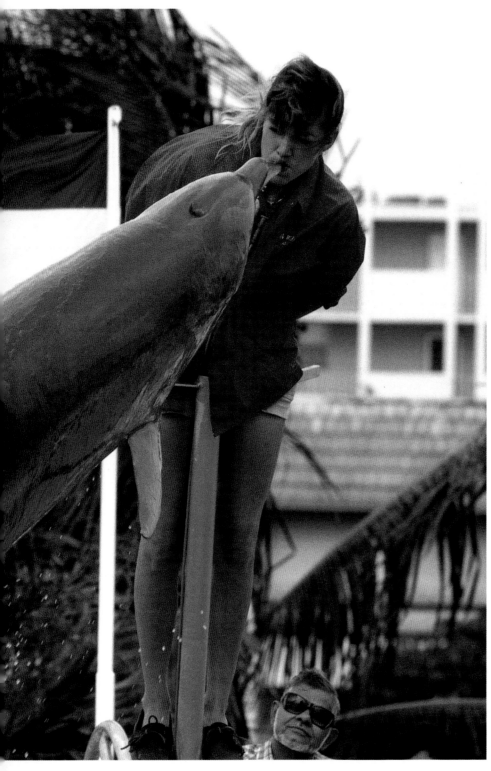

Exposing for a subject involves a number of factors. For this shot, timing was important, and, in order to freeze movement and to hand-hold my camera and 300mm lens, I needed a fast shutter speed. I used a fast film (ISO 400), a skylight filter, and an aperture-priority automatic exposure of f/11 at 1/500 sec. to capture this dolphin about to snatch a fish from the mouth of its trainer at Ocean World in Fort Lauderdale.

If you follow the rules in the data sheets that come with your film, the way to play it safe is to keep the sun over your shoulder and the subject in front of you. Of course, that's all well and good if you don't mind squinty-eyed expressions. But such portraits become commonplace before long. To prevent this, light your subject differently. There's nothing wrong with sunny days, or overcast days, or anything in between. It's how you place your subject in relation to the light that counts, as well as how you control contrast. And when the sky is less than bright, or when your subject is in the shade, you need to know what to do to add a little sparkle to the shot.

Working with Daylight

Outdoor lighting is as variable as the weather when sun and sky are your principal light sources. Shaded areas adjacent to open stretches of bright sidewalk, grass, or water are often good places to work because the open areas provide soft fill light that complements the soft light provided under the shade. This lighting condition also prevents faces from looking flat as a result of being uniformly in shadow, giving them some three-dimensional form.

If you are shooting out in the open on a bright, contrasty day, you may need to provide some fill light. Sidelighting or backlighting will illuminate one part of the subject, with reflected skylight and light from surrounding surfaces partly filling in the shadow area. Yet the extreme lighting contrast will almost certainly result in either washed-out highlights or blocked-up shadow detail, depending on the contrast ratio, your exposure, and the contrast characteristics of the film. Using either an incident-light meter (with its flat diffuser) or a gray card and a reflected-light meter, measure the light on both highlight and shadow sides of your subject's face. If there is a difference of more than two stops between the two readings, contrast is almost certain to be excessive. You will

then have to choose whether the highlight area or the shadow area is more important to your picture, and expose accordingly.

Reflectors can help lower the contrast ratio. You can use a white, silver, or gold reflector to add light to the shadow side or, conversely, a black absorbing panel to subtract light from the highlight side. If you're doing a head-and-shoulders portrait, the panel need be no larger than 2×3 feet, and it can even be held by the subject. A full-length portrait, however, may require a panel larger-than-life-size.

White posterboard can serve well as a reflector, either by itself or covered in silver or gold foil that has been crinkled and then flattened.

White provides a fairly soft fill light, silver is harsher, and gold adds a little warmth in the shadows. The black panel can be a sheet of posterboard covered in any absorptive material, such as matte black paper or black velvet. Use the black panel when the lighting is even, to create a little contrast, such as when the face is frontally lighted by the sun. The brightness on one side of the face is then reduced. One side of the board can be white, silver, or gold; the other, black. Where it is not practical for your subject to hold the reflector, use an assistant or a reflector with a support frame.

There are two alternatives to carrying around excessively large sheets of posterboard. The first is to buy collapsible, portable light-controlling panels. They do require their own frame supports and may need an additional light stand or clamp support. There are systems that form light-diffusion tents or domes around your subject. The other approach to outdoor light control is flash-fill.

Outdoor scenes on a hazy, sunlit day can be contrasty, so exposure becomes more critical than on an overcast day. In this portrait, the important subject area, the woman's face, is partly in sunlight and partly in shadow. I bracketed in one-third-step increments up to +⅔ EV for the TTL exposure. The bright jacket added some light, even a touch of red, to the shadow on the model's face. A skylight filter removed the bluishness from the shadow areas.

Photographing people outdoors against a bright background using a TTL reading can cause underexposure. For this portrait of an artisan on a beach in Puerto Rico, I overrode the exposure by one stop.

This outdoor shot of ice skaters in New York's Central Park required a +⅔ EV exposure override.

In the picture on the right, exposing for the background would have seriously underexposed the model, and exposing for the model would have overexposed the background. I determined that f/8 at 1/60 sec. would give me the background exposure I needed. These settings agreed with the flash-to-subject distance for my flash unit in the automatic mode and gave me a balanced fill-in flash exposure.

Flash-Fill Outdoors
A compact electronic flash unit is easier to carry around than reflector panels, although it does pose problems of its own. The effect is not easily visualized in advance, and the results are not fully predictable. Also, its use may necessitate some time-consuming computations based on subject-to-flash distances, and this can limit subject spontaneity.

On the positive side, flash offers lighting effects not possible with reflectors. A flash can fully illuminate the subject for a balanced-lighting look. If you're looking for something offbeat, you can attach a colored filter over the flash. A yellow or orange filter can maintain a twilight sky effect.

Correct Exposure Outdoors
The way you approach exposure with outdoor portraits will depend on how much of the picture field the subject occupies and how bright or dark the background is.

If you follow the old dictum—"shoot with the sun over your shoulder"—you're fairly safe with your camera's through-the-lens (TTL) exposure, if there are no brilliant ("hot") spots that might affect the camera's center-weighted exposure meter. Judge the scene for above- or below-average reflectivity, and bracket if you feel the need. An incident-light reading will serve you well when shooting under overcast skies and in the shade or with frontal sunlight. Simply point the hemispheric dome of the exposure meter at the camera from the subject's position. For sidelighting, I prefer the camera's TTL meter, but an incident-light reading should work, too. With strong sidelighting, try aiming the incident dome a little toward the light source. For a sidelighted subject, always bracket any meter reading.

Rim Lighting and Silhouettes

Light from behind the subject can have either of two effects. It can outline the subject with light or cause it to be silhouetted. In the former case, called rim lighting, the subject is edged in light. Exposure for the subject should not influence the rim-light effect unless you have grossly overexposed the subject.

While a good exposure for the subject is important with rim lighting, the background is the important area for silhouettes. Don't use an incident-light meter at the subject position (pointed back toward the camera)—the result would be a well-exposed subject and a greatly overexposed background. You should meter strictly for the background. With TTL exposures, strong sunlight or a bright sky could cause the subject to be silhouetted enough. If you're not certain, shoot again, giving less exposure this time.

Filters Outdoors

If you're using daylight-balanced color film and your subject is fully or partly in the shade, or under an overcast sky, you can add a skylight filter or an 81A warming filter to correct for the excess blue. Partial shade, as long as it does not tint the person's face, does not always require corrective filtration. The choice is yours.

Here, the camera's meter read the glaring late afternoon sunlight reflecting off the water and underexposed the people on the boardwalk in Coney Island, New York. The result: a silhouette. The bright backlighting even added a subtle rim-lighted effect.

Portraits: People Indoors

This image illustrates how soft umbrella lighting and placing a diffusion filter over the lens can combine to create a pleasing studio portrait. I used an 81B-series warming filter, and the ƒ/4 exposure was determined by an incident-light meter reading in the flash mode.

Making a portrait indoors is no simpler nor more difficult than doing it outdoors, although the degree of control may be greater. Indoor lighting encompasses a variety of forms, some as unpredictable as the light found outdoors. Available light comprises both window and artificial light, while supplementary illumination often comes from flash.

When contending with window light or available artificial light, you often have to deal with low light levels or strongly uneven lighting or, worse, light of the wrong color temperature. You might grab for your flash and expect it to cure your indoor-lighting woes. But this would be a mistake. And, although flash will let you capture candid moments, this form of light is often viewed as harsh, cold, and unfeeling. It might let you capture only a small part of the warmth and essence of your subject.

For studio-style portraits, flash does have its advantages. The light or lights are positioned to bring out the three-dimensionality of your subject. More often than not, the light will be softer, less contrasty than on-camera flash. Studio lamps offer endless possibilities. The relatively fast recycling times on studio electronic flash allows a person to move and change poses freely. Strength of the light output permits shooting at small apertures, giving sufficient depth of field to cover the to-and-fro movement of the subject, and the instantaneous motion-stopping burst keeps the picture unblurred. Available light rarely offers this combination of depth and speed.

Available Light

Light is an element you control. You have to learn how to deal with the existing light and then how to augment it or bypass it, should it fail to meet your needs. The greatest control you have over light is the exposure.

There are four principal forms of available light indoors: sunlight, skylight, incandescent lights, and

fluorescent lamps. Each type of light has advantages and disadvantages.

Sunlight is great, but it is contrasty. On the plus side, the color temperature is right for daylight-balanced color film, so you don't need to resort to corrective filtration. But that contrastiness cannot be overlooked. The problem can be made all the worse if you work with a film that is inherently contrasty. TTL in-camera readings and reflected-light hand-held exposure readings can be tricky,

almost pointing you toward incident-light metering.

"Almost pointing" depends on how much of the subject is brightly illuminated and how much is in shadow. A bright shaft of light streaming in through the window would cause a spot meter to inflate its reading, if it was a bright highlight that was measured; but an averaged reading of the subject would consider both light and dark areas. True, there may be more than average brightness to contend with in the sunlit part, but then you can

compensate by opening up the exposure. Then again, you can use an incident-light meter. It will give you a good exposure in any case.

No matter how you meter the subject, bracket in half-stops up and down to one full stop—more on the minus side, if you want a low-key effect.

By the way, if you want to avoid the harshness of the direct sun, don't overlook the possibility of lowering the shades or rearranging the blinds. Just be careful if the shades or blinds are not white: they might bleed their own color onto the subject. An off-white like beige should not be a problem—it would have a slightly warming effect—but strongly colored materials could be.

When direct sunlight is out of the picture and all you have left is skylight, you have a much softer source of light, but one that can still create relatively harsh contrasts. The degree of contrast depends on how reflective the walls and other surfaces are, and how well they serve as fill-lights. (Colored surfaces won't help as reflective surfaces because they can impart a color cast—unless you want that added tinge.) You should also consider the person's proximity to the reflective surface: it won't have much effect if your subject is positioned even a few feet away.

You can obtain a measure of lighting contrast either with a spot meter and a gray card or with an incident-light exposure meter with a flat diffuser. The gray card or diffuser should be read when they are oriented toward the light source and again toward the camera. Determine the difference in EVs between the two readings. The actual exposure reading can best be done with an incident-light exposure meter aimed toward the camera from the subject's position,

As the afternoon progressed, the light streaming in from the window to the model's left did not allow me to use even a reasonably fast shutter speed with an ISO 400 film. The incident-light meter gave me a reading of f/2.8 at 1/30 sec. I explained the problem to the model, and she held perfectly still.

Shadows can be a problem even when the lighting is soft and diffused. In this portrait, I used a commercially available white reflector in its support frame. There was enough shadow remaining on the right side of the subject's face to retain the modeling effect—a result of the studio flash light.

with its regular dome-shaped diffuser in place. But if the sun and clouds outside are playing a game of hide-and-seek, they'll disrupt that carefully planned exposure reading. In that case, compare the incident-light reading with a TTL reading, apply the difference on the autoexposure compensation dial, and shoot in TTL automatic. Make sure to take the TTL reading without any filters on the camera, or at least nothing stronger than a skylight filter, which has a negligible filter factor.

If your main light source is incandescent or fluorescent lamps, you will, of course, be concerned with corrective filtration with daylight film. But the main problems are that this light is uneven and can be contrasty.

Since subject and background reflectivity are factors with TTL exposures, be prepared to make some adjustments if the subject-background relationship changes; in other words, if the subject moves closer to or farther away from the camera. The tonalities of the subject or background may come more prominently into play at this point, and this would affect the exposure.

The easiest way to control contrast, other than repositioning the subject so that light coverage is more even or standing the subject right next to a white wall, is to use a reflector card or panel. You can use posterboard, formica, or any stiff flat-surfaced material. The length of the sheet should be equal to the subject being photographed, but 2×3 feet is a good starting point for a head-and-shoulders portrait. Indoors, a reflector panel becomes a simple matter to position and work with.

Place the reflector on the shadow side of your subject. Once you determine the ideal position, find a support. I've used a chair and a small stepladder for an upright panel, but you can also position the reflector flat on a table for a head shot or head-and-shoulders portrait. The subject can even hold the card, as long as you make sure that it doesn't show anywhere in the picture and that the subject's arm position doesn't make it obvious that he or she is holding something.

On-Camera Flash

Any shot that resembles a formal portrait virtually dictates that you avoid using on-camera flash, even used on a bracket. The heavy shadows that result are often quite objectionable and can even make it difficult to distinguish between the subject and the background. For example, when you photograph a person with dark hair with direct flash, you'll notice a background shadow that merges with the dark hair. If the person is wearing dark-toned clothing as well, the problem is worse.

Direct flash could also create shadows that cover up other important areas, such as a second person partly hidden by the first. The shadow might cut right across the face. Also, if there are people a considerable distance behind the principal subject, they will be poorly illuminated because of the way the light falls off.

Working with the flash unit in automatic, I preset my lens aperture and the flash-to-subject range to cover the widest practical range of distances. This makes it easier to take candid portraits.

DEVELOPING RAPPORT

Photographing someone for the first time is as uncomfortable for your subject as it is for you, especially if this is your first meeting. It doesn't matter how many times you may have talked to each other before the session, or even if you have mutual friends. The person who is about to pose for you always asks himself or herself, "Can this person really photograph me? Is this photographer wasting my time?" You may be asking yourself similar questions if you are slightly intimidated by an unfamiliar situation, even with a person you've known for years.

To do the job right, you have to develop a rapport with your subject. Talk to the person, and treat that person as something more than just an object to be photographed, whether you are doing the shoot for the fun of it or whether you are being paid—or even if you are paying a model. Explain what you're doing, ask for ideas, and be open to feedback. Smile and be complimentary: tell the person a shot looks terrific. A joke or two always serves as an ice-breaker, but only if it's spontaneous.

Establishing rapport is part of your preparation for the shoot. Get everything ready at the outset, and know where things are to make finding them easier if you need them later. A well-organized camera bag is a big plus. Keep your equipment in one location. Rapport also means showing that you are in control and that you have confidence in your abilities. If you make a mistake, joke about it and repeat the shot. If

you need to repeat a number of shots, just tell your subject that you would like to try something a little different, for the effect, or that you want only a few more shots. You may be able to squeeze in those extra few, but don't tax the person's patience. The subject's comfort should always be first on your agenda.

It's amazing how much more relaxed and cooperative a subject is once you establish rapport—and how much better the pictures turn out.

Once you establish rapport with the person you're photographing, any technical problems seem less troublesome and the shoot becomes a collaborative effort. Share your ideas with the model, and ask for his or her opinion. Having a good working relationship with the model can only improve your pictures.

Bounce Flash

Bouncing the light off the ceiling, or some other nearby white surface, is one way to increase the reach of the flash and to create a softer lighting effect than with direct flash. You can still operate the on-camera unit in the automatic mode, as long as the sensor is facing the subject. If, instead, the sensor is aimed at the reflecting surface, the exposure will be off considerably: the sensor will read the wrong surface. To avoid this, switch to manual flash operation, taking into account the effective distance the light travels to the ceiling or wall and from there to the subject. (Without doing any arithmetic, simply focus your camera on the ceiling, or whatever point the flash is aimed at, note the distance on the focusing ring, double it, and make your manual flash exposure. With that distance in mind, use the flash's calculator dial to compute the *f*-stop necessary for the exposure. Bracket by adding one-half to one stop to allow for the light lost to the reflecting surface and for any miscalculation.) Obviously, using a flash meter is simpler.

One problem you are likely to encounter in bouncing light from the ceiling is deep pockets of shadow in the eyes. They require fill-in illumination and either a reflector or a secondary flash can provide it. My choice is a reflector because it lets you see what the effect of the fill illumination will be and if this will be a problem. Adding another flash can only complicate matters, even if it is built into the main flash as a subordinate light source.

To overcome the harshness of direct on-camera flash, you can aim the flash head at a white reflective surface; I used the ceiling in the photograph directly above. But this creates pockets of shadow around the eyes. To fill in these shadow areas, you can add a reflector. The model in the large picture above held the reflector. Also, I opened up by half a stop to enhance the high-key effect.

Studio Flash

This type of flash offers the most versatility in portrait lighting. The flash can be a single unit with an umbrella or a light bank. Either can vary the degree of softness of the light. If fill-light is necessary, use a reflector or a secondary flash set up as a slave in synchronization with the key light. Other lights, all slave-synced, can be positioned to light the background, add catchlights to the hair, or provide other effects.

Base your exposure on an incident-light reading of the main light output, using the hemispheric dome. Then check for lighting contrast: Take readings with the flat diffuser on your exposure meter, or spot readings off a gray card. A visual check, however, will probably tell you all you need because studio lights are fitted with incandescent bulbs that serve as modeling lamps to help you see where the shadows will fall. (With 35mm instant slides now available, you can even make a film test before going ahead with the portrait.) Become acquainted with the inherent contrast of the film you're using before deciding on a lighting ratio. It might permit a higher ratio or necessitate more fill light.

Filter Use with Color Film

Unless a subject is fully illuminated by sunlight, key areas will probably not show true color on daylight-balanced film. Skylight exposures may require a skylight or 81A warming filter, and you might prefer this when using flash-fill, as well.

Exposures on daylight film under incandescent lighting will record the subject with orange or orange-red colors. As such, using tungsten-balanced film might be a better choice.

Avoid fluorescent lights as illumination for color film: the color cast is often greenish, and correcting for it is difficult without a meter to measure color temperature. You do have other alternatives, namely flash—and black-and-white film.

I began this series of images on black-and-white instant slide film and decided to do another in color: the models were as enthusiastic about this shoot as I was. Having decided to soften the light from the studio flash unit, I aimed the flash through a diffusion panel and placed a diffusion filter on the lens to increase the softening effect.

Portraits: People in Action

Many activities require a photographer's anticipation of the critical moment in an event and, often, a working knowledge of a sport. But there are also lulls in action. Frequently, there isn't enough light available for stop-action shots. This means you have to improvise. Exposures can be tricky, with deceptively bright backgrounds or even bright clothing or uniforms. Depth of field may be limited because you want to both stop movement and use long telephotos that can "reach in there" and "pull" the subject into the camera.

Water Sports

Shooting people around water depends on where you're standing—or sitting—when taking pictures. If you're on a rocky boat, you first have to make sure that you can provide as firm a support as possible. Next, for hand-held shooting you have to see that your shutter speeds are at least as fast as your lens is long. Even if your feet are planted firmly on the ground, along with your camera, don't overlook bright skies, water, and white sails that may cheat your exposure. Open up one-half stop or more to keep your whites white, not

18 percent gray, when the situation becomes questionable, and bracket where possible. Whether or not you're using a tripod, consider using slow shutter speeds to blur action—yet a surfer caught riding the edge of a wave in a frozen moment in time looks equally impressive.

Take a few precautions. Unless your camera is in a waterproof casing, use telephoto lenses when photographing oncoming waves. On a boat in choppy seas, watch out for salt spray, which can corrode metal parts of the camera, eat away at the coating on the lens or filter (it's a

Photographing windsurfers is one thing; photographing them from a moving boat is something else—and much more difficult. I relied on my camera's TTL exposure system to make this shot at f/5.6 at 1/500 sec. with a 300mm lens.

good idea to use one here, plus a lens shade), and perhaps seep into the camera or lens. Wipe drops of water off immediately.

Land Sports
Here, all depends on the background. Photographed against a uniformly illuminated trail among the trees, a hiker will come out correctly exposed. But when the area behind is brighter or darker, there's a risk of underexposure or overexposure. Use an incident-light reading if you can, or take TTL readings of the subject from camera position and from close up, to judge how much the background may affect the exposure.

A climber on bare rock offers two obstacles to a good reflected-light exposure: the sky and bright rock. Be prepared to compensate for excessive brightness. At high altitudes, bare rock can be quite reflective and can inflate the reading by a stop or more in bright sunlight. Bracket exposures on the plus side for insurance.

When you photograph skiers, exposure compensation on the plus side for a reflected-light reading may be anywhere from ½ to 1½ stops—more may completely wash out the snow. The exposure correction depends on the relative amount of snow in the picture. For an incident-light reading, shoot at both the recommended meter settings and minus half a stop to compensate for the excessive brightness that the snow throws onto the subject. Shutter speeds can be fast or slow, depending on the effect you want.

Fast-Action Sports
These sports put you on the edge of your photographic seat. Aiming your lens at a specific spot in anticipation or at a specific player and follow-focusing requires hair-edged alertness, a finger resting firmly but gently on the shutter release so you don't suddenly jam down on the button and blur the picture. Seated in a stadium, you may find yourself in a tight squeeze, with just enough room for a monopod; this is a necessary support for the long lenses (300mm

To photograph this crew raising the sails, I needed to consider the brightness of the background and to use a fast shutter speed to freeze the action.

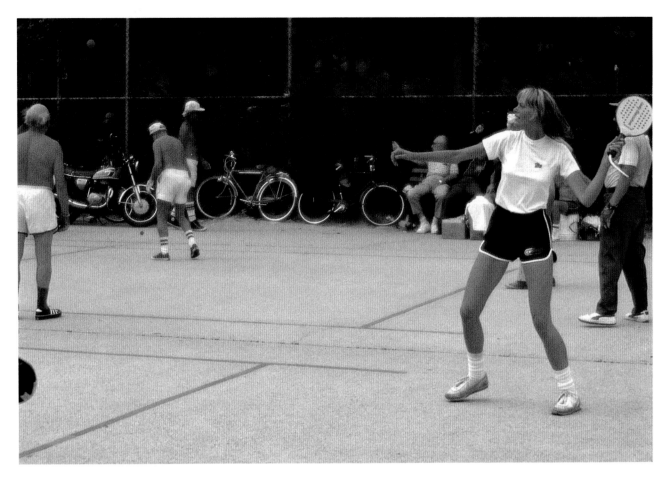

Like most fast-action sports, paddleball requires you to keep your eyes on the players and the ball at the same time. This shot is effective because the ball is in play. But tight closeups of the players can also be strong.

or more) and relatively long shutter speeds you'll likely encounter (perhaps as slow as 1/60 sec. with an ISO 400 film pushed to EI 800, even under bright stadium lights). To make matters worse, the lighting on the playing court or field may not be even, and brighter or darker background areas—not to mention uniforms and clothing—can also influence the exposure. Where the light is evenly distributed take a spot reading of a key area, or meter the highest and lowest brightness areas and average the two; then follow through with manual exposures based on this. Using flash during any professional game or match, of course, requires special permission.

Film Choices
Indoors and outdoors under artificial lights, fast film is needed in order to freeze fast action; nevertheless, a slower film can produce effective blurred effects, especially when you pan with the subject's movement.

Artificial lighting always poses color problems, it's best to call ahead and try to find out what kind of lights are being used. You can also go to the game and experiment for a more important occasion in the future. Some color negative films, in particular the ISO 400 and faster ones, are designed to give satisfactory color results with any light source within reason. If you must get the shot this time though, play it safe with conventional black-and-white or chromogenic black-and-white film.

Daylight gives you more leeway in your choice of film, but you might need a skylight or 81A warming filter for snow or for gray skies.

Self-Portraits

Camera manufacturers make allowances for photographers who like to get themselves into the picture. I'm not sure whether it is a matter of vanity or, truthfully, just plain fun.

Self-portraits, however, can be a hassle. You have to set up the camera, run into position, and then wonder if you got it right— especially the exposure. Is that something you overlooked entirely? Did you just set the camera on automatic and expect the best?

You probably stand a better chance of an exposure error on the under rather than on the over side when setting up the camera for a self-portrait. Mostly these are taken outdoors in front of some scenic background; this means that the sky or some other bright backdrop is behind you. If the background is fairly neutral, an ambient-light TTL

The easiest way to photograph yourself is to photograph your reflection. Here, I chose a spot with a fairly neutral background, so exposure would not be a problem, and then aimed the camera at the mirrored glass panel.

GETTING YOURSELF IN FOCUS

The easiest way to achieve proper focus for a self-portrait is to find a substitute that can be positioned in your place. If you are part of a group shot, you already have a principal subject. If this is a solitary effort, look for a chair that can be moved into position, either to use temporarily or to use for the shot. If you expect to be leaning against something, focus on that. Ideally, you should focus very slightly in front of the "leaning post" to avoid throwing yourself out of focus ever so slightly. Then close the lens down one or, preferably, two stops to ensure correct focus by increasing the depth of field. Don't stop down too much or you might bring distracting background details into the picture. Be sure to study the background in order to eliminate unnecessary details. You can't take everything into account beforehand, especially if you are outdoors and are surrounded by moving cars and people, but you can limit your variables considerably.

For self-portraits, find a spot you like and either focus on something already there or an object placed there that can be removed easily or used as a prop. To ensure sharp focus, stop down as much as possible. I made this self-portrait (photo left) next to an ice slick on the Tuckerman Ravine Trail in New Hampshire's White Mountains. Although I bracketed anyway, the snow was not a dominant exposure factor and did not necessitate any exposure compensation. For the shot on the right, I focused on a point on the rock, and then got into the picture. I prefer to use self-timers with long delays in order to have enough time to get to just the right spot.

exposure with a center-weighted camera meter should do. But you'd better bracket plus and minus one-half stop as insurance.

Self-portraits taken against bright backgrounds with a basic TTL center-weighted exposure are almost invariably underexposed. If you want to look less conspicuous and have the background stand out, you might still have to open up one-half to one stop to prevent underexposure in some important parts of the scene, other than yourself, that are in shadow. Flash fill may be used.

An incident-light reading is the best way I can think of to guarantee that you'll be correctly exposed. Take the reading either at your position as subject or at the position where you have the camera on its support, provided the light is uniform at both places.

If I had followed my camera's TTL reading alone for this self-portrait, I would have been underexposed because of the bright background, as I am in the shot on the left. I compensated by opening up one stop in the shot on the right.

Portraits: Pets

Pets are generally no different from other candid subjects to photograph, unless they are trained to stand or sit in one position. But they do present certain difficulties with exposure. If your lens does not focus close enough, the background may interfere with correct exposure. If you can focus close enough, the brightness or darkness of the animal may adversely affect your exposure reading. As you will see, however, there are solutions.

Black, White, and In-Between

A good exposure for a furry, hairy, or feathered animal, whatever its color, does not have to pose any serious problem to a TTL or hand-held reflected-light meter. A bright white coat or shiny black feathers can create some problems, but just consider the deviation needed from a neutral-gray exposure. A healthy black or white coat on an animal requires an exposure adjustment of about 1½ stops, plus or minus, respectively, in relation to the background and to the sheen on the coat. If the animal is mottled black and white, with fairly even distribution of both colors, the situation is fairly ideal.

Other colors tend to be less problematical, but treat pale pinks and bright yellows with the same attention to exposure detail as you do white, with an eye toward correcting for potential underexposure.

Wire Cages

The major problem with these enclosures is shooting through the wire. The trouble is compounded when the pet is active. But you can make the wires seem to disappear by using a wide aperture—the wider the better—and holding the lens as close to the cage as you can. This does give you a better chance to use a shutter speed fast enough to freeze action. But it also means that any movement may put the animal out of focus. Remember that depth of field is minimal at maximum aperture, especially if you are also using a closeup diopter lens attachment or other means to get closer to the animal for a "tight" portrait.

One solution is to open the cage; but be careful when you poke a lens through the door or even hold it up against the cage: a bird may peck at a highly reflective object, such as a lens. (If the pet is not yours, ask about the bird's propensity for such behavior. If the reply is uncertain, keep clear.) Any reaction to the glass in the lens will

AVOIDING UNDEREXPOSURE

My first experience with photographing animals was with my cat, Prudence. She's basically all white, except for the eyes and tinges of pink showing at the ears and nose and other areas. My initial exposures proved fairly disastrous—all underexposed. I hadn't stopped to think about all the things I had read, such as that the in-camera meter reacts to excessive brightness by underexposing. I found that I had to open up my exposures by between 1 and 1½ stops for many shots; this was needed more with negative material than with slides. Underexposure in slides tends to show off more of the texture in the cat's fur, but by varying the exposure corrections, I now get a range of good results. I just make sure not to overexpose, which would wash out all the detail and texture in the white fur. Of course, had I known then what I know now about making exposures, I would have used an incident-light meter.

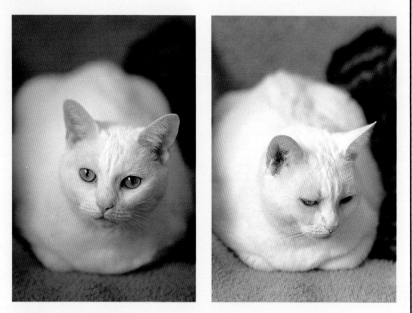

Because reflected-light meters are keyed to read 18 percent reflectance, a bright white subject, such as my cat, fools them into underexposure. Incident-light meters give more accurate readings. For these shots, made with available light, the incident exposure reading was ƒ/2.8–4 at 1/15 sec.

Aside from your photographing through an open cage door or letting the pet outside the cage, the only practical way to bypass a wire cage is to get as close to it as you can. Use a short telephoto lens or macro lens at its maximum aperture to throw the wire out of focus. Try to photograph the animal closer to the front of the cage, so the wire will be less visible.

only make the situation more difficult from a photographic standpoint and may result in irritating the animal.

The other solution is to take the animal out of the cage. This only works for animals that are not nervous.

Aquarium and Terrarium Pets

A TTL exposure is the best for available-light photographs of fish, reptiles, amphibians, and other small creatures in glass enclosures. Daylight may not always be possible, but that would simplify one part of this type of photography. You wouldn't have to concern yourself with changing light levels from one part of the tank to the other—unless rocks, plants, ornaments, and the tank's water filters blocked the light. Aquariums and terrariums are naturally brightest nearest the light source at the top; this can lead to excessive contrast.

But there may not be enough ambient daylight in an aquarium for most films, other than the fast emulsions, and most aquatic subjects are always moving. Also, most aquariums are kept out of direct sunlight to prevent or control the growth of algae. (If algae do grow on the walls of the tank, clean the insides off with materials approved for aquarium use before taking pictures.)

On the other hand, sunlight-tolerant reptiles and amphibians that live in terrariums are in a perfect environment for ambient-light exposures. Shutter speeds of 1/30 sec. or longer can even be used with these creatures, who may remain stationary for long periods. It is usually only when they are about to pounce on their prey or attack a piece of lettuce that faster shutter speeds are required. But even then you can use a shutter speed of 1/15 sec. to 1/30 sec. to capture the attack as a blurred movement. Take, for example, an Old World chameleon that, with a flick of its tongue, captures a cricket. The chameleon remains completely stationary as its tongue uncoils to lash out at and, usually, to capture its victim with the utmost speed and efficiency.

I took this shot with available light, which did not leave much room for focusing errors. Because of the large aperture and the slow shutter speed, I had to use a tripod to keep the camera steady These chameleons were difficult to photograph because the mother refused to stay still.

This picture also required a large aperture and a slow shutter speed, as well as a tripod. I got the tortoise where I wanted it by putting a piece of lettuce in the tank.

Many aquariums and terrariums have an overhead reflector to provide light. The fixture may be fluorescent (often a pinkish, sunlight-simulating type) or incandescent. This light obviously does not work well with color film—unless you don't mind distorted colors. Another problem with overhead lighting is a result of the inverse-square law: Usable light decreases with distance. This makes it difficult to use anything but a TTL camera exposure. Also, in terrariums and in aquariums with fish near the top of the tank, strong contrast results from overhead lighting. Reflective sand or gravel can, however, provide sufficient fill in many cases.

With available light, whether artificial or daylight, you can see the effect. Many such environments have ornaments, driftwood, or plants that may block light and create shadows. A continuous light source reveals where shadows are intrusive.

Using Flash
Electronic flash can be used with some pets but should be handled with discretion. The flash probably isn't harmful; however, if the sudden burst of light startles, annoys, or agitates the animal, avoid it.

You shouldn't use flash to shoot through cages. The light is likely to cast shadows from the wire onto the animal. Also, the light will be reflected in the wire, if not in front then certainly at the back of the cage, resulting in distracting bright points in the final image. Finally, flash often uses relatively small apertures, which only draws attention to the wire in the cages.

Electronic flash can also freeze movement and provide the color balance for which a daylight film is intended. When shooting aquarium pets, you will find that flash proves most effective for aquariums if the water is clean. Suspended particles show up as spots or, to be more exact, numerous small but disturbing, out-of-focus, flaring reflections that veil the subject. Aquarium water may be greenish from the presence of algae, and in that case will be color-tinged no matter what the light source.

The placement of your light source depends on the number of flash units you have available to do the job. If you use one flash head, place it above and to the front of the tank. Many aquariums and terrariums use clear glass covers. Wire mesh covers are used with reptiles. Opaque plastic lids are also used, but you should try to have them replaced with the clear glass or wire mesh for picture-taking. When shooting fish, wait until well after feeding time, to avoid churned up water. Make sure that plants or objects do not block the light. (If you are just setting up an aquarium, do it with picture-taking in mind: set the plants and ornaments to the back; this is generally recommended, anyway.)

You can also light the tank from the front. Place a flash at a 30-to-45-degree angle to the glass. Place your lens right up against the glass of the tank. If you place the flash on a bracket that can be angled comfortably to the glass surface, you have a light source that can move with the camera. However, placing it on a support independent of the camera will work just as well.

Any time you remove the flash from on top of the camera, you encounter the problem of getting correct flash exposures through the flash unit's autosensor. Always be careful that it is not reading glaring reflections off the glass tank. For best results, use a flash that has a removable sensor. Mount this on the camera's hot shoe, but then be careful that the flash head itself is not positioned closer to the subject than its recommended minimum distance. If you find you have made this error, move the flash away from the tank. You can achieve more reliable results with TTL flash metering.

With non-TTL flash exposures, don't forget to compensate for any lens extension you added for closeups. If you use a polarizer on the lens, factor that into your exposure as well.

You might think that you can use a front-of-the-lens-mounted flash, either a ring flash or twin flash, pointed at the front of the tank.

While this may overcome the problem of having light bouncing back into the lens, you still have to contend with the glass at the back of the tank, a second reflective surface that could produce glaring hot spots in your picture.

If you have two flash units, place them at a 30-to-45-degree angle to the front of the tank to the left and right. Holding the camera up against the glass should cut down on glare considerably, at least from the front wall. This arrangement provides a more uniform light. You can use a lens hood of sufficient size to block out stray light and reflections in the glass from the lens's direct view.

With fish, never use floodlights because they raise temperatures unbearably. I'd even recommend against studio electronic flashtubes because the modeling lamps give off heat. You can, however, use these lights with reptiles that thrive in hot climates.

Multiple-flash can be metered in several ways. If two flash units are wire-synced to a TTL flash system, you get a fairly reliable exposure. If they are not, you first have to slave-sync one flash to the one connected to the camera and use a hand-held flash meter set to make reflected-light readings. If you use a flash meter under these conditions, I'd recommend a spot reading off the subject. Moving subjects require more patience and more bracketing, but the flash-to-subject distance should not vary appreciably. Try to meter an area as close to neutral gray as possible, or, if the environment is dry, put a gray card inside the terrarium and read various points on the card. This will give you a more complete exposure guide in the event that the animal does move around.

Problem Aquatic Subjects
Few aquatic species are exposure problems in and of themselves. But there are some to watch out for, such as fish whose coloration is silver, bright yellow, or black. These can pose exposure problems, especially when you want tight closeups. When you use slide film to photograph brightly colored fish,

give one-half to one stop more exposure than that indicated by a spot meter; give another half stop if you use a negative emulsion. For deep black fish on color-slide film, give one-half to one stop less exposure. But negative material should tolerate the overexposure.

Silver-sided and light-colored species can also be a problem with flash: they can wash out by reflecting too much light. These fish should be lighted with a careful eye for potential problems.

Anticipating Exposures

Many pets are quite active. But they are also creatures of habit. If they move around, they often follow more or less the same route over and over. This tells you where to train your lens. Try to predetermine the exposure or at least the probable exposure correction needed. Squeeze down on the shutter button gently and, as soon as the animal reaches your chosen spot, release the shutter.

Some animals are attracted by food, favorite toys, or sudden noises or movements. Use any of these to get an animal's attention or to lure it to a certain spot. Always be ready with the camera prefocused and your finger poised on the button.

Fast shutter speeds may be required for some animals while others will hold still for relatively long periods. If movement is imminent and fast shutter speeds are not available or a tripod is impracticable—or if you want to try something different—then go for a blurred shot, either by panning with the movement or by holding the camera still. Either effect should prove interesting. Try to use a tripod, though, if you are photographing an animal that is sitting or lying still.

CAMERA INS AND OUTS

Even if you place a polarizing filter on the lens—which is not always practical—it's doubtful that you can eliminate all the reflections bouncing off the glass facing the camera when you shoot by daylight. But if you are working with the light in the tank, shoot in a darkened room and use the lens as close to the glass as possible to cut the reflections further. In light or dark, shoot squarely into the glass enclosure. If you do have to angle the lens, angle it downward to avoid picking up any stray reflections your eye may not have noticed before shooting.

The lens should have closeup-focusing capability. The most useful focal length is 85mm to 90mm. Used at or near the lens's maximum aperture, this lens length will tend to throw any additional distracting details on the glass out of focus. A wide-angle lens that can be placed up against the glass will also work well, but use an extension tube or closeup diopter lens attachment with it to limit its depth of field as much as possible—you may not want to see the back of the tank and the wall behind it in focus. Don't use ultra-wide-angle lenses with bulbous front elements because the two glass surfaces will most likely come into contact with each other. Besides, the angle of view would probably take in more than the enclosed habitat.

Zoo Photography

Many zoos now provide simulated natural environments for their wildlife inhabitants. This means fewer cages with heavy bars and more open-air exhibits and glass enclosures. Yet there are still cages even in some of the finer zoos and the lighting often proves far from ideal. In naturalistic environments, the surroundings may be improved for the animals, but for the photographer it can still mean poor lighting because of light-blocking trees and shrubs. Furthermore, environments for nocturnal and crepuscular wildlife provide a minimum of light for viewing. In many of these situations you'll be tempted to use flash, but don't do it without checking the rules first: it may be forbidden. Nocturnal animals see at night because the pupils of their eyes dilate fully. In addition, these animals are sheltered from lightning by trees or other parts of their surroundings. The effects of that bright, sudden burst of light could not only frighten or annoy the animals but also harm them. (You may see other people using flash, but if you looked close, you might find that they were using compact cameras with minimal flash output. The burst is not as powerful as the one emitted by the unit in your camera bag. Still, that is not really an excuse.)

Another deterrent to flash photography in zoos comes from the photographic standpoint: few subjects are in a clearing free of intrusive branches, rocks, or other animals. These intrusive elements can block the light. As an alternative, use the available light: take along a monopod (it doesn't get in people's way and cause them to trip and injure themselves—but if you happen to have a tripod already, use it with the legs collapsed into a single thick leg). Take along fast film for indoors and even a fast telephoto lens (180mm $f/2.8$, for example) if you have one.

The best time to go picture-taking at the zoo is in the spring or fall. In the spring, many birds build their nests and animals give birth to their young. In both seasons, outdoor foliage is less abundant and more colorful. Avoid weekends as they are the most crowded, unless you go on a rainy or severely overcast day that deters potential visitors. Expect to encounter groups of children during school months. So try to avoid crowds if you can; if you can't, don't linger. Be considerate of other people wherever you go in the zoo, and most of all, be considerate of the animals: don't yell or make noises or faces at them. Don't even smile at the primates—they interpret a toothy grin as a threat.

This green tree python sat coiled in a perfect pose. To capture it, I used a 90mm macro lens and a TTL front-mounted twin flash. However, the snake reacted to the flash, so I suggest that you don't use powerful electronic flash units with reptiles.

Outdoor Environments

In these areas little, if anything, hinders daylight from providing sufficient illumination for many well-exposed pictures. On a bright day, a medium-speed film—ISO 100 to ISO 200—can serve you well, even if you use telephoto equipment of at least 300mm. There is often a railing or concrete divider separating you from the animals, which you can use for support. You don't need very fast shutter speeds. Speeds of 1/125 sec. (even slower, if you can handle yourself well with a monopod) will work well, because many of the animals don't move around much. TTL camera exposures are more than adequate; however, you have to watch out for bright backgrounds that may call for some exposure compensation.

On cloudy days or in situations where the animals may be in the shade, it may be more difficult to achieve a shutter speed of 1/125 sec, especially if you're working with a slow telephoto (f/5.6, for example). Your best bet might be to switch to a faster film. Before loading the camera, set the film-speed dial at a higher ISO setting for the faster film you plan to use, activate the meter, and see if the exposure will prove sufficient. If not, consider going even higher. You can push a slide film if you must, but you shouldn't have to go beyond ISO 400 for most outdoor situations. It might be best to shoot color negative film of a similar speed: at the same ISO rating, films for prints have a tighter grain structure than films for slides. You can, of course, always use a black-and-white film, or use a chromogenic black-and-white film and rate it at EI 400 or 800 to achieve good results.

In this outdoor environment at New York's Bronx Zoo, these polar bears were surrounded by snow. This threw off my camera's TTL exposure reading. I used an autoexposure override of +1 EV for this shot, which was made with a 90mm lens.

SAFARI PARKS

Drive-through wildlife safari parks represent a cross between true wildlife photography and zoo photography in some respects, yet in other ways they resemble neither. You can unexpectedly have a large animal come right up to your car one minute, while you strain to get a good view of another, distant animal a moment later.

The drawback to drive-through parks is that you have to keep your car windows rolled up. A seemingly harmless ostrich can inflict a painful jab with its beak through an open window. Wildcats are a more obvious danger. But if you do a good job of cleaning the car windows before entering the park, you have a good chance of getting some effective wildlife portraits. Just try to shoot as squarely through the glass as possible. Watch through your viewfinder for the edge trim around the windows and for reflections off parts of the car; these can cause vignetting or flare, respectively, in your images.

I have had success with lenses in a range from 90mm to 300mm, but there have been times when I have wished for a faster telephoto lens. If you have an f/2.8 180mm or 200mm lens, bring it with you (although you'll still need something longer on occasion).

Because most park areas are open to the sky, you can often capture movement with a film of ISO 200. Don't lean against the car because the motor's vibrations can go through you to the camera and blur the image. Instead, brace the camera against yourself, elbows pressed firmly against your chest.

The easiest animals to photograph are those standing, sitting, or lying just a short distance from you. The more difficult ones are those crossing your path. A motor drive on the camera is always helpful under these conditions, but it won't help you with the focusing of a conventionally focused camera. A useful technique is to prefocus on a spot in the direction the animal is headed, and when it gets there, to release the shutter, using a fast shutter speed. You can also pan—move with the animal's movement—using a slower shutter speed. This will show the animal relatively well defined against a blurred background. Or use a fast shutter speed, to freeze all the motion. If you happen to be in the park in the last hours of daylight, you may be lucky enough to capture a flurry of movement, since a number of animals become more active at this time.

In this shot, the adult baboon's eyes are expressive and deep, and virtually hidden. Traveling light, I carried only a 100mm lens with me.

I kept two cameras loaded with film on a drive through Lion Country Safari in West Palm Beach, Florida. One camera had a f/2 90mm macro lens; the other, a f/5.6 300mm optic. Long lenses enable you to bring in animals that shy away from the car, whereas macro lenses in the telephoto range are useful for closer animals. I photographed these lions (photo above) with the 90mm lens at maximum aperture, at 1/125 sec.

Indoor Environments

These areas normally offer moderate to low levels of light, the dominant source usually being either daylight (indirectly, the sun) or incandescent lights (floodlights). At some zoos, floodlights kick in when daylight begins to wane. You need films of ISO 400 or faster because the smaller animals in many of these enclosures often move about regularly. With few exceptions, you don't need lenses exceeding 100mm in focal length. Because they are generally faster than your longer telephotos, the speeds at which they can be hand-held are more manageable—remember the reciprocal rule for hand-held shooting discussed earlier on page 65:

1/Focal Length = Shutter Speed.

If you find yourself having to use a slow shutter speed, try to make the most of it. Follow the animal with your camera. When the subject is moving more or less parallel to your line of sight, release the shutter (using a shutter speed of 1/15 sec. to 1/30 sec.) and pan with the camera.

Enclosures as Obstacles

There are a safe way and a risky way to photograph animals behind bars and wire mesh: to get close and to get too close. Observe the rules, and keep to the perimeters designed for visitor safety. Telephoto lenses used at or near maximum aperture will throw bars and wires out of focus in most instances. If you position the lens so that it squeezes through the opening between wires and bars— "squeezes" only in the sense that you center the lens's view there and still keep it (and yourself) at the prescribed safe distance—you can be pretty much assured that the extraneous details won't show. However, if the bars or wire reflect strong sunlight, resulting in specular reflections, you may get flare in the picture. This possibility is greater with wire than with bars.

With glass enclosures, follow a course of action similar to that for aquarium and terrarium photography. These enclosures are often acrylic or some such plastic—a material that scratches more easily than glass (this is also true of some home aquariums). In addition, the glass may not be as clean as you like, so finding the perfect shooting spot may be a compromise between a good position on the glass and a good composition involving the subject.

To avoid disturbing your subjects, keep the lens from bumping into the face of the enclosure when you press it up against the surface. As you position the lens, or when you want to reposition it, put your little finger out as a feeler. This facilitates camera movement that is safe and not intrusive.

Because working with available light was impossible here, I opted to use flash. But a low-power unit did not add enough depth of field for this shot of a crocodile. I had to use the maximum aperture (f/2) on my 90mm lens for an ISO 50 film in order to cover the distance.

I photographed this young bird (photo left) with a 28mm lens on my camera. Afraid of losing the shot, I didn't have time to change lenses or add closeup accessories to gain the closeness and image size needed. With the minimum focusing distance of the lens setting my close-focusing limit, I could not place the lens flush against the glass. As a result, I caught some reflections in portions of the picture.

The reptile house is perhaps the only place at the zoo where I feel comfortable using flash—but again, only if no restrictions are placed on its use. Since you obviously can't position a flash unit on top of the enclosure or devise any setup with multiple flash, either hand-hold the flash or mount it on a bracket attached to the camera and angle it toward the subject from the left or right, or even downward. If an automatic light sensor is involved, insert it into the camera's hot shoe. Another device that works well is a flash unit that mounts on the front of the lens; keep its autosensor on the unit, if it is not a TTL unit. TTL flash exposures speak for themselves.

Film Choices

Aside from shooting in black and white to overcome the problems of color balance, as well as to create an image that emphasizes tonal and textural relationships, you can generally use a daylight-balanced color film. Most zoo environments are illuminated by skylight. There can be mixtures of daylight and floodlights, but I don't see any practical sense in using a color meter to find a filter combination that will work. (Besides, filtration wastes light and necessitates even faster films.) If an incandescent light source (floodlight) predominates, use a tungsten ("indoor") film for a better color-balanced rendition, or use daylight film and get warmer colors.

Problem Subjects

You will never be able to photograph certain animals successfully because of the environments in which they are found. Without special permission to use flash or an authorized person to provide access to certain animals, you'll just have to make do with memories and postcards. The only other problems, aside from insufficient light, that you'll encounter are bright bodies of water, sand, snow, and distance.

A TTL exposure reading of a subject against an excessively bright background requires about one to two stops additional exposure, depending on how much of the picture field (the area that affects the meter) is concerned. For example, think about polar bears in snow or white ducks on a pond. Specular reflections off water may not always seem important, but they can throw a meter off as much as direct sunlight can. Sand and snow may require some exposure compensation as well, depending on the amount of space they occupy and their reflectivity, which is much greater on a sunny day.

The Bronx Zoo's Jungle World exhibit has a number of simulated environments. In this one, the brightly painted backdrop would cause a TTL meter reading to be underexposed by one stop. Realizing this, I used a +1 EV override with the camera in the aperture-priority mode for this picture of silvered-leaf monkeys.

Aquariums and Oceanariums

Like the zoo, an aquarium or oceanarium comprises a variety of controlled wildlife environments. Unlike the zoo, the focus here is on inhabitants of watery environments, principally salt water. Also, unlike a home aquarium, everything is generally on a grand scale.

Restrictions on the use of electronic flash are generally relaxed, but it's always best to find out exactly what they are. Because of outdoor shows and sea mammals, the equipment and techniques that come into play are as varied here as they are at the zoo.

Outdoor Habitats

Approach semiaquatic species in outdoor environments as you would any other subject. Consider the need for corrective filtration under an overcast sky or in shade; watch out for distractingly bright concrete structures and reflections in the water; and note that sea mammals out of the water actually reflect less light when wet than when dry— except that in bright sun they can throw off specular reflections, hot spots that could cause your meter to read too much light and lead you to underexpose.

Indoor Habitats

These areas usually consist of a main exhibit hall with ocean and freshwater tanks of various sizes. Subdued lighting reduces the number of unwanted reflections in the glass—even though, it is most likely acrylic, which, unfortunately, scratches more easily than glass. Watch for doors leading outside: they may let stray light in when opened.

One potential problem in aquariums is churned-up sediment. This causes no real problem when you are shooting by available light, but with flash it is another matter. Light reflecting back from the suspended particulate matter acts like hundreds of tiny mirrors, creating what is, in essence, flare (it's called backscatter in underwater photography).

I photographed this dolphin in the feeding tank at Fort Lauderdale's Ocean World. The animal's highly reflective skin gave a TTL exposure reading of f/11 at 1/250 sec. on ISO 400 film, but I repeated the shot with a +1 EV override, shown here. Either exposure would have worked well because of the dolphin's uniform color.

Bluish water can be warmed with a CC20R filter—but I recommend keeping the water blue. (After all, how else can you give the pictures a true ocean feel?) Hazy blue water can cause underexposure if you use a reflected-light reading; but try shooting at the metered exposure and then at half a stop and one full stop more.

Available Light vs. Flash

Light levels in all aquatic displays are weak, even for an ISO 400 film. Flash is generally called for, but don't forget that it presents a problem in some tanks. I feel safest using flash with tropical species in tanks free of suspended matter. You can photograph stationary subjects, such as anemones, corals, and rockfish, with either available light or flash.

Don't use flash when photographing sharks, dolphins, whales, or other large aquatic creatures in an underwater environment. The main problem is backscatter when these animals are in the water. Don't forget that the greater the distance between you and your subject, the lower the visibility—in large tanks—just as in fog. Another factor that may hinder you from getting the sharpest picture is the tank's acrylic walls. They are quite thick and can never be as clean or as scratch-free as you'd like them to be.

Outdoors, shoot by daylight. Avoid flash on a wet animal: it can create hot spots that you'll see only after the films are processed.

Daylight vs. Tungsten Film

Interior aquatic displays may be illuminated by both incandescent (tungsten) and fluorescent lighting or by either. Start with a daylight film when you have no additional information concerning the type of lights used. Daylight film should be used for open-air tanks—you'll know them for their bluish water, and you'll see portholes (or complete access to the outside) that allow shafts of light to enter during the day. The lighting may change here to indoor lights, however, as daylight wanes.

Because this fish (photo above) remained still for some time, I had ample opportunity to take a manual reflected-light flash reading with a hand-held meter. Having bracketed exposures, I selected the +½ EV exposure, which best captured the fish's tonality.

The shark tank at the New York Aquarium is illuminated by an overhead skylight. When you use flash, suspended particles create backscatter. Aware of this problem, I chose to work with available light for the top shot on the opposite page. I braced my 28mm lens against the glass and waited for the shark to come into the picture. With the coral reef fish (bottom photo), I encountered an entirely different situation. Low levels of light and unknown light sources dictated using flash; this brought out the full color of the fish and ensured blur-free results.

Wildlife Photography

Setting out to capture wildlife on a frame of film is, to me, one of the ultimate challenges in photography. A natural environment—where wildlife walks, runs, or flies unhindered by artificial boundaries; where wildlife follows the light of day or night—are replete with opportunities and difficulties. Each environment poses its own problems and requires its own approach, as does each wildlife subject. The basics are: first, the environment and second, the specific wildlife species. The environment tells you the kind and amount of light you have to work with; the species tells you what lens you need and how fast the shutter speed needs to be to capture your subject.

Telephoto Exposures

Some habitats lie under open skies, while others are under or part of a canopy of treetops. Still others are completely dark. The creatures that live in these habitats may be easy to find or elusive; they may be found by the light of day or in the twilight hours, or at night. Few animals make themselves available to the photographer, and those that do are often of an imposing size on the ground or else they're in the air, or they present a threatening nature—and almost all keep themselves at a considerable distance.

You'll do best with faster and more powerful lenses, but without a faster lens, you have the option of choosing a faster film. You'll still need long telephotos, in most cases: 300mm and longer focal lengths, both refractive and reflex mirror optics.

A good, sturdy tripod or, at the very least, a monopod will be necessary because shutter speeds with an ISO 400-speed film can run as slow as 1/125 sec. early and late in the day in an open environment.

Wooded habitats, of course, prove more difficult, but some of the larger woodland inhabitants, such as deer, can be found grazing at the edge of the woods in the early and late hours. You can also find rabbits and hares at these times, along with many other mammals. Reptiles, which are coldblooded, like to soak up the rays of the sun early in the morning.

The best times to photograph many birds are morning and evening. Waders and swimmers feed during these hours, although parents feeding their young are out at all hours of the day.

I photographed this bird on an autumn day at the Jamaica Bay Wildlife Refuge in New York. It was late in the day, and the scene was tranquil. I made this exposure with a 500mm reflex lens, with the camera on a tripod.

Photographing some animals requires a long telephoto lens. I used a 500mm mirror lens in order to capture this garter snake.

THE WILDLIFE EXPERIENCE

Photographing wildlife requires a great deal of patience. Very few animals will come to you, and you cannot go right up to most animals without eliciting the fight-or-flight response. You have to step lightly and slowly, with your camera at your eye, changing focus as you approach your subject. Wait a moment after each step you take, and watch the animal's responses. If the animal moves away or even just eyes you cautiously, hold your ground. If it continues to go about its business, take the next step. As you approach the animal, its wariness of an intruder will increase. One step too many, too fast, or too noisily will cause the animal to back away or take off.

If you are really patient, stand still and wait for the animal to return. Some do. You might consider waiting a short while before progressing toward an animal that has returned, or you might fare even better holding to your fixed position in hopes that the animal's foraging will take it closer to you. This is not the time to start fiddling around with your equipment, pulling out a different lens or another camera. The excessive movement and noise will scare the animal away. If you carry two cameras around your neck, make sure they don't knock into each other and create a noise.

On one of my nature hikes in Brooklyn, New York, I chanced upon a snowy egret in a salt marsh. I watched and waited patiently for it to come nearer so I could get a tighter shot. I didn't realize that the tide was coming in, and I suddenly found myself surrounded by water. I almost panicked, but I collected myself and my gear. On subsequent visits, I explored other parts of the marsh and went away with a rewarding experience each time.

A recent trip to Florida was another worthwhile photographic experience. I spotted a group of ducks at a lake behind a friend's house. I was within two or three feet for some tight portraits. After I finished and thought that the ducks had gone away, I found myself being followed by the entire entourage back to the house. That's the kind of loyalty a photographer likes. (But I think all they really wanted was their modeling fees.)

Many animals that live in urban areas are unafraid of people, up to a point. Geese, ducks, and squirrels allow you to get close enough to take tight wildlife portraits. But you have to be patient and wait for the animal to approach you. They want to be fed. Some animals, though, leave as quickly as they came when they realize that they won't be getting any food.

Dim Light and Darkness

With dusk approaching, or in the thick of a forest, you may be tempted to resort to flash. Flash can be used, of course, but it puts greater demands on your time as you wait for a frightened subject to return or for another to take its place. If you can use the ambient light, do so.

Flash has more of a place in specialized nighttime photography. Depending on the remote triggering device, movement, sound, or vibration can set it off and fire the flash (or motorized camera) connected to it. If the camera is not motorized, you will have to set the shutter speed at "B" for a timed exposure; this means no lights anywhere around. It also means having to recock the shutter after each exposure.

If you don't mind leaving things to chance, you can connect a motorized camera to an intervalometer to make fixed-interval firing every few seconds, minutes, or hours, and to do this automatically over the course of a few minutes or hours. For best results, plant the camera in a spot where it will be likely to capture something worthwhile. Make sure that the intervals used allow the flash enough time to recycle.

Film Choices

When photographing wildlife, you first have to choose between color and black and white. And if color is your medium, you have to choose between prints and transparencies, and then decide which color film. Because your subjects are outdoors, daylight film suggests itself. In terms of film speed, you may be interested to know that many successful wildlife portraits have been made on ISO 64-speed emulsions, while others have been shot on higher-speed films—ISO 400, for example, perhaps pushed to EI 800.

Take all factors—environment, subject, lens, and ambient-light conditions—into account before putting a roll of film into the camera.

You might decide to use a skylight filter over the lens, both for protection and to correct colors for subjects in shade, but that is not always necessary. I do not, however, recommend using anything stronger, such as an 81-series filter, because of the unnatural color it may impart to the subject. With nature, as with snow, the colder (bluer) quality of light can work well. It depends on the subject and on your feelings about it.

Taking advantage of a photographic blind at the Jamaica Bay Wildlife Refuge, I watched this cardinal stop at a feeder (photo above). I was testing an ISO 1000-speed slide film at the time. I rated the film at EI 2000 and used a 130mm to 650mm zoom lens, for which I brought along a sturdy tripod. The day was blustery, but the blind provided some protection from the wind. As the cardinal chewed on a seed, I used an exposure of f/16 at 1/500–1/1,000 sec. A slower film undoubtedly would have blurred the seed husk as it fell from the bird's mouth.

This mockingbird nest (photo right) was cleverly hidden in a dense shrub and was dimly lit. The lighting problem was solved by using a mirror, which would give more directional illumination than a flash unit. The mirror bounced enough additional light onto the nest for me to make this shot.

The City by Day

Large city or small, the urban landscape by daylight is filled with contrasts, textures, and colors. These are sometimes subtle, and the contrasts and colors can be limited to shades of gray, white, and black. Many buildings stand out by virtue of their size, shape, or design. They may be fronted by water fountains, statuary, or gardens. The streets they are on may be either bustling with activity or sparsely populated. Potential subjects abound.

All of these factors play a part in how you photograph the city by day—and what you photograph. With people in the way, you may have to use a longer lens from a greater distance and a tripod to support the camera with that lens. If you decide to work with a wide-angle lens, you may need patience as people walk in and out of the picture and the sun ducks in and out of clouds.

Any city, no matter how busy or how quiet, requires a shooting plan. Explore the area you wish to photograph, familiarize yourself with it, study it, see what is especially pleasing to the eye, what may work better with one type of light or with another. Always look around—in all directions—as you walk. Retrace your steps in the opposite direction: you may discover something new. The lighting may be different or the camera angle may present a fresh approach. What if the streets are too empty to convey the feeling you wish to convey—or too busy to let you focus on specific details? Even if conditions are not ideal, take the picture anyway—just to keep a record, and as a visual reminder.

There are times when you have to take the opportunity of the moment. You don't always have the luxury of returning when the creative whim strikes, such as when traveling. But that doesn't mean that you don't have to be observant.

When I saw the mirrored glass on this building, I knew I wanted a picture of it. I would have preferred more blue sky and fewer clouds, but as it turned out, there was enough blue sky to provide a contrast to the whiteness of the clouds reflected in the glass. I made the exposure using a 24mm perspective-control lens. Bracketing aperture-priority exposures in one-third EVs gave me several good images.

Stark and Subtle Contrasts

A sunlit deep blue sky fairly free of pollution creates some of the starkest contrasts possible. Colors everywhere become intense—they stand out from each other sharply. Street scenes can offer a combination of brightly lighted and shadow-strewn areas, making it difficult to produce one exposure that will serve both areas equally and bring out detail in all the important parts of the scene. If half the scene is in bright light and the other in deep shadow, you may have to make a choice and expose for one and let the other go. An exposure favoring the highlights will yield good detail on the bright side of the street. But—unless you don't care at all about the shadow side— you should still open up about one-third to one-half stop more. This will open up the shadow side enough to show some detail, yet will not wash out the highlights on the bright side. Bracketing helps. A center-weighted TTL camera exposure that includes some blue sky will most likely give you a highlight bias, unless you point the camera so that the meter reads mostly shadow area.

Low contrast, as seen in this shot of a building in Old San Juan, can make a picture a little darker (with a TTL exposure reading) or a little lighter (with exposure compensation) without ruining it. Bracketing exposures gave me several good shots. The picture above is the +⅔-stop exposure, which seems to best represent the scene as I remember it.

High contrast may cause a loss of detail in part of a picture, as shown in this shot of a building in New York City. This depends on the amount of contrast, the film, and the exposure.

Interior and Exterior Contrasts

Sometimes the contrast between highlight and shadow can be such that compensating for one will lead to a definable loss in the other. For example, when photographing a bright exterior that opens into a dim interior, exposing for one will mean losing valuable detail or color in the other.

Brightly toned and deep black or dark building exteriors will affect the meter reading in a reflected-light measurement. Generally speaking, brighter subjects tend to require more care in exposure than darker ones. The reason is simple: the sun or skylight will tend to reflect off any surface, especially any windows, and this will more than counteract the dark tones of the building. It might even be enough to cause underexposure when a glaring hot spot, such as the reflection of a bright sun in glass, becomes evident, requiring more exposure to reveal the true facade of the building.

As I was leaving this restaurant in Old San Juan, I decided to photograph it from the outside looking in. I encountered a major obstacle: the brightness of the outer wall. My camera meter read that brightness and underexposed the restaurant's interior.

The spacious entrance to the shopping mall in the picture below was another matter. The entrance admitted quite a bit of light and enabled me to record adequate detail. The atrium in the center of the mall also helped.

Because the sun was fairly low in the sky, providing a bright backdrop, I aimed a spot meter at the sky and exposed accordingly. The result: a silhouette of this statue located at the entrance to the El Morro fort in Old San Juan.

Special Features

Statues will often require more careful exposure than the face of a building. Many statues stand above eye level, often against a bright blue sky. Silhouettes based on an exposure reading of the sky are always effective, but to capture detail, take a reading from the statue itself. If you're using the camera's meter and it looks as though a lot of skylight is pouring into the picture, open up by one stop, and then bracket exposures.

Every urban landscape also has its share of water fountains. Ambient brightness will dictate whether or not any exposure compensation is necessary. Study the whiteness of the water: if it is considerable, it will throw the meter off toward underexposure. Is the fountain structure itself throwing off its share of light? Is the water highly reflective? These factors will determine how much, if any, exposure compensation is necessary. More often than not, any exposure compensation will be toward the plus side, requiring more light.

Most city scenes can be safely and effectively metered with your camera's built-in meter. But spot metering comes in handy in contrasty situations in which some detail will almost invariably be lost and yet you want to ensure that important detail is retained. Take spot-meter readings of key highlight and shadow details. If you meter only for the highlights, be prepared to lose shadow detail, and vice versa. If you feel strongly about both bright and dark areas, then take the average of the highlight and the shadow readings. You could also look for a middle tone to train your meter on. That is easier said than done, however, because the eye is not trained to read areas of 18 percent reflectance. Our visual system can readily respond to brightness and darkness but, except for squinting in bright light and dilating the pupils in the dark, the eye has no way of telling you when you've reached a happy medium. That comes from experience. Once you've gained it, you can shoot for the midtones—but bracket for insurance anyway.

Many urban settings are also replete with landscaped gardens. Government buildings are often surrounded by them, and office buildings may feature interior landscaping. You should have no problem outside, as long as you don't overlook the sky at the top of the picture, or bright brickwork or masonry, or pools that may be part of the landscaping. Keep an eye out for trees that cast shadows and cause uneven lighting. Indoor gardens lighted by daylight require only a careful hand when shooting against the light. If indoor lighting provides the main source of illumination, remember that it is often uneven, and it pays to bracket your TTL exposures. Spot metering might be useful, but instead of averaging readings, shoot for the most important and the brightest parts of the scene.

I photographed this fountain in New York City late in the afternoon, using a tripod and a 28mm ƒ/1.9 lens, with the camera in the aperture-priority automatic mode. I stopped down the lens to ƒ/5.6 for greater depth of field. This gave me a shutter speed of 1/15–1/30 sec., which blurred the water somewhat, as you can see in this shot. Bracketing plus and minus 1/3-stop did not produce markedly different results.

The City by Night

I originally intended to shoot the New York City skyline at dusk, but I found a spot that offered this view. I thought this was a perfect opportunity to use a full-frame 16mm fisheye lens on my camera, which I mounted on a tripod. In the darkness, I couldn't at first tell that the exposures exceeded the shutter-speed range for my camera in the automatic mode. But as I changed apertures, I realized that the shutter speed was the same for too many shots. I then set the lens at its maximum aperture and made several exposures in this f-stop range. I used the fisheye lens's yellow filter to add a touch of color.

Cities at night can be dazzling sights. In some cities, the waning of daylight heralds a multicolored display of lights. They may be flashing, flickering, or constant, and the view may be close to you or distant. But for you and the camera, this display presents a challenge.

Exposure determination is the tricky part of nighttime photography. Bright—and not-so-bright—lights alternating with patches of complete darkness make it difficult to assess the situation accurately. Often it's a judgment call, but bracketing allows you to create images that meet or surpass your expectations.

The easiest time to photograph a display of city lights is at twilight.

Then, contrasts are minimized. The sky is neither bright nor dark, and the same can be said of the city streets. A TTL exposure should prove more than adequate. Watch out for glaring lights directly in front of the lens and for reflections of sunlight in windows or from light-colored walls—these can throw the meter off toward underexposure. If there is a glaring hot spot in the picture, simply open up by a half to a full stop and bracket. You don't always have to override the exposure—the rich contrast makes for a stark image. If you do wish to adjust the exposure, don't open up by too much or you'll burn out all the subtle color of the twilight sky and the city lights will take on an

unusual burning intensity.

When nightfall is fully upon the city, every light becomes both boon and bane to camera metering systems. Spot metering may come in handy for street scenes with patchy lighting photographed through a normal or a wide-angle lens, or through a short-to-medium telephoto from a considerable distance. In this case, manual operation may prove more beneficial should oncoming traffic or other lights come between you and the part of the scene that interests you. Experience has also taught me, however, that I could just as well rely on the camera's TTL automatic operation, with some bracketing thrown in for insurance.

In many cities, famous buildings are illuminated with floodlights, either partially or in their entirety. A center-weighted TTL exposure should suffice when the entire building is illuminated. When only the upper part is covered in lights, consider taking a spot reading. On the other hand, wide-angle views that include both bright and dark areas have proven successful with simply a TTL exposure.

Fountains at night can be photographed successfully with TTL exposures, provided that there is also some surrounding area dark enough to compensate for the brightness of the water display. If you focus only on the water, open up from one-half to one stop, depending on the brightness, and bracket your exposures as well.

Urban Reflections
Rainfall is often something photographers try to avoid. After all, rain can damage the camera. But rain opens up a whole new world of reflections for the camera. Rainy scenes, with fair distributions of reflected light, can be metered in the camera. But, as always, watch out for hot spots that may originate more from the street than in the reflections.

Film Choices
Daylight or tungsten color-slide film can be used for night shooting, and if you use a tripod, you don't even need a fast film. Don't worry about

This statue of George M. Cohan in New York City's Times Square reflects the lights from the illuminated displays surrounding it, especially the one to the left. At first I thought that the statue itself was too dark and needed less exposure, but bracketing indicated that the background and reflected lights balanced the dark and the light parts of the scene.

I prefer to use daylight-balanced film at night. I think that the distorted colors add a richness and brilliance to the image, as seen here, that tungsten-balanced film does not.

AMUSEMENT PARKS AT NIGHT

Located in Brooklyn, the amusement park that I grew up near, Coney Island, is within the city limits of New York City. Consequently, I think of the amusement park as a part of the city. Whether amusement parks are situated in urban or rural areas, they have rides, games, and food stands—only the names are different.

There may be more bright lights here than in an average urban location at night, except for Las Vegas; but they are often of an unimposing nature from the standpoint of exposure. As a result, a TTL autoexposure is adequate (but bracket to find the exposure that works best for you). Bright lights, flashing or not, that are centrally concentrated can, however, affect exposure adversely. For these you might need an extra stop, more or less.

Exposures may not be too long for hand-held shots, but you'll need to use a tripod to achieve blur effects with longer shutter times and to use slower, longer focus lenses.

For this shot of an amusement park ride at night, I needed a slow shutter speed, which gave a sense of motion. I used my camera's TTL metering system, and, despite the prevailing darkness, it accurately read the colored lights and reflections and gave the proper exposure. I used a tungsten-balanced film here.

Daylight was waning fast, so I set up the camera on a tripod and bracketed exposures for this view of a harbor in Saint Thomas.

color rendition because colored lights are already contributing to unrealistic hues. If you want to try to adhere more to the color of the illuminant, try a tungsten-balanced film. Using color-conversion filters to adapt a daylight film to tungsten lighting may result in more of a light loss than you want, especially for hand-held exposures. No matter which film you use, you'll still discover that colors may not be rendered accurately because the lights may not conform to the 3200K tungsten balance you were expecting—the result of

fluorescents, sodium vapor and mercury vapor lamps, and other kinds of incandescent lights.

Ultra-high-speed color-slide films, ISO 1000 and faster, are contrasty, and all of them look grainy. In my opinion, color negative films in this range are a better choice. For black-and-white photography, an ISO 400-speed film should serve your purposes well, without excessive contrast. You might also consider a chromogenic black-and-white material to cover the broader spectrum of light levels you are likely to encounter.

Interiors and Window Displays

Many city buildings have unique interiors and may even have shops with windows that face outside. The only problem here is that indoor and display lighting is often so uneven that high contrasts result. The eye can easily discern objects, but film will show the uneven differences in lighting. These subjects, then, appear to pose insurmountable problems. In actual fact, they offer only minor stumbling blocks to the creation of a well-exposed image.

Daytime Exposures
Daylight facilitates shooting architectural interiors. If enough light filters in, it may fill in the shadow areas: the places the artificial illumination does not fully reach. Auxiliary lighting is impractical, unless you have a bank of studio lights to work with, and no on-camera flash is adequate for an entire interior.

Daylight helps with window displays, too. But, if practical, use a

Light filtered in from outdoor areas on both sides of this reception area in a government building in Old San Juan (photo above). I decided to make this fisheye view with the camera mounted on a tripod. Bracketing was not necessary for this low-contrast subject, but it did prevent the meter from being thrown off by the predominantly light colors.

I noticed I had one more shot remaining as I started walking up the steps to a New York subway platform. The combination of the full-frame fisheye lens and fluorescent lighting resulted in the distorted and ominous view on the left.

When an interior is illuminated by incandescent light in one section and daylight in another, you are bound to have exposure problems. In this interior view of a Florida shopping mall, daylight filtering into the foreground helped to diminish the contrast somewhat, but the background was still much brighter. Bracketing exposures gave me images in which all the detail in the shadow areas was visible, others in which it was partly visible, and still others in which it was almost completely obscured. This picture has good detail in most of the foreground areas, yet the background is not washed out.

polarizer to screen out some of the street reflections that appear in the glass.

In terms of film selection, consider whether correct color rendering of the artificial lights or of the daylight is more important. Remember that the interior lights may not all be incandescent. Black-and-white film works well with many interiors. A tripod is useful for slow films, especially for blurred-motion effects when moving-water displays are present. The same film choices apply to window displays, for much the same reason, although I'd recommend sticking to color film to record colorful arrangements. Avoid filters for color, since some of the more interesting effects become evident as a result of the distorted hues.

Exposure for Contrast
Despite contrasts and unevenness in lighting, either a TTL center-weighted or a hand-held averaging reflected-light exposure will produce good results. Because of the contrasty lighting, however, it is smart to bracket. You may find that one exposure will give you what you want, but bracketing in one-third to one-half stops both up and down—but no more than one stop either way—will give you a choice that lets you place priorities on parts of the scene you feel are more important. Try to keep bright light sources out of the meter's field of view in order to prevent underexposure.

With window displays without daylight fill, you'll find that floodlights illuminate one part of a display much more than another. Therefore, you'll have to decide which part of the display is most important and expose for that. If the lighting wraps around the window, all the better. (You'll also have to choose between daylight and tungsten film.)

With either interiors or window displays, spot readings of key areas should prove highly successful. You can meter a key highlight or shadow area (or both, then average the two), but I'd still recommend bracketing. With any exposure metering other than TTL, don't overlook the filter factor the manufacturer recommends for your polarizer when you shoot window displays—especially if you use a hand-held meter.

Natural Landscapes

Natural vistas offer wide-ranging photographic opportunities, but equally intriguing are the more intimate details found in trees, rocks, and streams. You can photograph mountain ranges or find a face in a tree; you can capture the sweeping movement of a waterfall or the stillness of a lake. Natural landscapes open the door to your imaginative powers: they have light and shadow, shape and form, texture, tonality, and color. But they can play tricks on exposure meters.

Landforms and Trees

Photographing mountains, gorges, boulders, and other landforms is not difficult—unless the lighting is contrasty or there's a bright sun or sky in the picture. You can successfully photograph distant mountain scenes if you take the bright sky into consideration. If the mountain is facing the sun or if the sky is overcast, there is little problem with the exposure. If, on the other hand, the mountain is backlighted, you may need to use a spot meter or to point the camera meter downward to avoid a meter reading that is overly influenced by the bright sky. Of course, if you focus on the face of the mountain and eliminate any trace of sky, your exposure will prove satisfactory.

When photographing rock formations you need to watch out for their high reflectivity; it may throw exposure meters off by a stop, more or less. Don't just look for bright skies: dull weather is great for capturing the subtle colors of rocks. And, you will find that sidelighting makes the rocks look three-dimensional.

Trees are no more or less of a problem, but there is a greater possibility of backlighting. This works well with trees to create silhouettes, but you'll need frontal or flat lighting to capture details in tree bark. Here again, sidelighting adds an interesting element: the interplay of light and shadow on the bark. Leaves photograph well under any kind of light, but make your exposure for the leaves, not for the background, unless you want them silhouetted.

I liked the contrast of light and dark in this scene, as well as the interplay of the clouds and branches. I allowed the bright background to silhouette the tree to enhance the contrast.

In the shot on the left, backlighting was a factor, which could have been a problem. For the picture on the right, I made two exposures, using an ISO 200 film, a 90mm lens, and my camera in the aperture-priority mode. The sunlit side of the tree, shown above, was shot at f/11, two full stops brighter than the f/5.6 aperture needed for the shadow side.

LANDSCAPE EXPOSURE GUIDE

Subject	Spot-Meter Reading (in EVs)	Equivalent Exposure (ISO 100)
Snow Scenes		
Sunlit snow	15⅔	f/13, 1/250 sec.
Snow in shade	13⅔	f/13, 1/60 sec.
Forest		
Sunlit patch	12	f/8, 1/60 sec.
Shaded area	8	f/8, 1/4 sec.
Mountain with blue sky		
Mountain	13⅔	f/13, 1/60 sec.
Blue sky	14⅔	f/13, 1/125 sec.
Sunlit meadow	13½	f/13, 1/60 sec.

These readings were taken in the White Mountains of New Hampshire, with a spot meter. Exposure adjustments, based on a subjective appraisal of key subject areas, may have to be made.

Still Water

Water can reflect sunlight as much as any mirror can, but it can also reflect nearby trees and rocks, as well as the sky and clouds overhead. Water can also appear as a black abysmal mass, absorbing more light than it reflects.

When the water reflects sunlight, it becomes a blinding light source and causes severe underexposure if you rely only on a reflected-light reading. In order to compensate, open up your lens 1½ stops, or 2 stops maximum.

But depending on the angle you're shooting from and the sun and sky, the water may form a vast blackness, causing the metering system to overexpose the scene. This would require between one-half and one stop less than the reflected-light exposure meter tells you.

On the other hand, whether or not you use a polarizer, the water may reflect (or the scene may include) just enough of the sky to give you a balanced exposure between light and dark. One major exception is a river or lake surrounded by snow. The brightness of the surrounding area could lead to underexposure for TTL meters; give it an increase of one-half to one stop in the exposure depending on the brightness of the snow. You can intensify the "depth" of the water by using a polarizer. With a TTL exposure, bracket to minus half a stop, depending on the brightness of the surrounding area.

In this New Hampshire scene, reflections from the sky dilute colors in the water as well as other parts of the picture. The most practical solution was to use a polarizer. Because the camera was on a tripod, I wasn't concerned about the slower shutter speed that would be caused by the use of a polarizer. The resulting photograph has rich tonalities throughout.

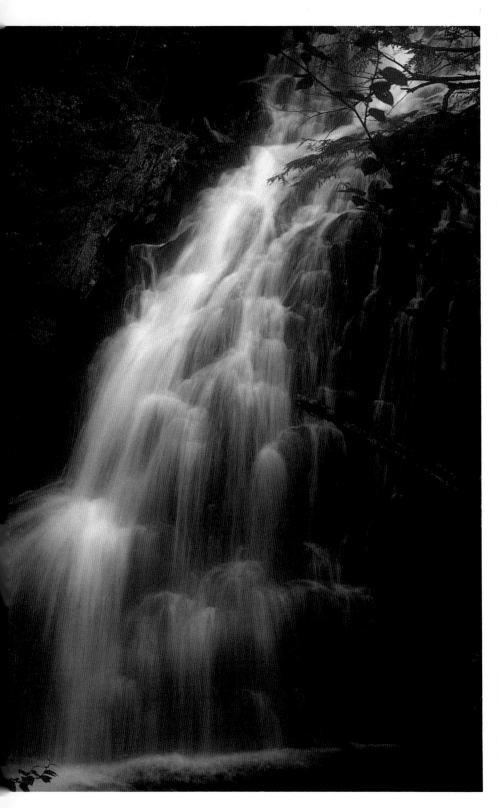

Moving Water

Unlike still bodies of water, for which hand-held exposures and fast shutter speeds work well, water in motion has a unique quality when shown as a blur. But this requires a tripod, slow shutter speeds, and slow film (or a faster film used with a neutral-density or polarizing filter).

There are few obstacles, besides finding a good viewpoint and withstanding spray from a waterfall, and exposures are generally straightforward. Picture areas to watch out for are highly reflective rock and white foam, both of which will throw reflected-light readings off in the direction of underexposure. Begin by opening up half a stop, then more if there is strong sunlight reflecting off the foam or rock or less if the falls are a mere trickle or if the rock does not figure prominently in the sensitivity pattern of the camera meter. No exposure compensation should be necessary if the brightness is balanced by areas of deep shadow.

Water sometimes calls for a sense of the dramatic, such as a powerful wave frozen as it crests or comes crashing down on the shore or against the rocks. Here, a fast shutter speed—1/250 sec. or faster—will work well. To capture the foamy texture of a waterfall or a raging river, shoot at between 1/125 sec. and 1/60 sec. For the milky whiteness of blurred falling water, use between 1/15 sec. and 1/2 sec.

This waterfall, called "Crystal Cascade" and located along the Tuckerman Ravine Trail in New Hampshire, is an excellent subject for a photograph. I chose to shoot it on an overcast day. Using a slow film, I selected a slow shutter speed for this shot. A tripod was, of course, a necessity.

The Sky

Vistas in which the sun, moon, and clouds figure prominently are often the most dramatic. Yet these same landscapes can prove the most troublesome because the exposure may be overly influenced by the bright blue and white of the daytime sky or the near blackness of the evening sky.

Many atmospheric phenomena add an intriguing element to the landscape, but you can readily photograph only a few of them—ones that can either be photographed by daylight or that generate light themselves. What is especially interesting with these phenomena is that they rarely appear the same way twice.

The Sun

Before you begin, remember that looking at a bright sun can damage your eyes permanently, especially if you look at it through a long lens. You should also be aware that pointing a long telephoto lens at the sun for a considerable period of time can burn a hole in a rubberized shutter curtain, in fact. So be careful and extremely cautious if you follow any of the next few suggestions.

The sun is tricky, no matter how prominently it figures in your pictures. Point a camera or a reflected light meter in the sun's direction, then move it a mere fraction of an inch and watch the exposure change dramatically. (If you use a spot meter, aim it to within a few degrees of the sun, *not* pinpointed on target.) Clouds moving overhead will further affect exposure, but, generally speaking, you should let the sun determine the exposure for a sunscape. Bracket toward the plus side in one-third or one-half stops to no more than plus 1½ stops. Also, vary the position of the sun in the picture, so that it has different effects on the exposure, and simply shoot at the metered exposure.

Sunscapes taken in the first and last few hours of day, both after and preceding twilight, take on something of a sunrise/sunset appearance, with the color of

A 300mm lens and a sturdy tripod enabled me to take this aperture-priority exposure of a sunset. Any exposure compensation would have weakened the rich color of the sun and its reflection. Shadow detail was unimportant in this picture.

I had to use a 2X teleconverter for this shot in order to increase the lens's 600mm focal length to 1200mm. Obviously, I had mounted the lens onto a tripod.

daylight being warmer. While the color is a more-or-less predictable tan or brown, it could just as easily be nearly blue or even yellow-green, depending on the film's response to light—without using any filters whatsoever.

To add an unusual touch to your sunscape, turn your aperture dial all the way to the smallest *f*-stop. At this aperture, pinpoint sources of light become stars—without the use of a star filter. If your lens stops down to *f*/22, use that for the star effect of this solar system's star attraction. If the small aperture limits the range of shutter speeds to one too slow to hand-hold, use a tripod. However, that will not often be the case. The effect works best with a high, brilliant sun, not one lying low on the horizon, tinged

with the colors of dawn or dusk.

Sunrise and sunset can be difficult times for shooting. A setting or rising sun leaves foreground objects in silhouette. The silhouette effect is often an advantage in a photograph, but not always. That's when you have to know to adjust your exposure on the plus side. But remember, the more you increase exposure to compensate for the sun's brightness, the less rich the colors of early morning and late afternoon or early evening will be. Bracket in half stops, but not more than 1½ stops total. At +2 stops, colors fade to pastels and look washed out. Even though the scene reproduced on film may truly represent what the eye saw at the time, it may lack interest as a picture.

The Moon

Unlike the sun, in which pointing the camera or a hand-held meter anywhere near it will lead to a reasonable exposure, exposures of the moon are not as easy. If you aim your camera at the full or near-full moon alone, the resulting exposure may be a quantum leap off or it could be fairly on target, depending on the focal length of the lens in use. A spot meter aimed at the moon will encompass some dark sky along with it and will be off. The best solution is to bracket exposures up to one full stop either way from your meter readings.

An alternative is to photograph the moonscape by daylight. At the times when the moon rises before darkness has set in, you can rely on the last rays of the sun to provide sufficient light for an exposure that brings out good detail in both the moon and the landscape. If you want more of a night-sky effect, underexpose the image.

Clouds

These are fascinating subjects, taking shape and form with the wind. They can be overwhelming in grandeur or delicate and unassuming. They can appear ominous or almost beatific. And they can always do a job on your metering system if you're not prepared.

Some clouds are not so much white as layers of light and dark tones. A color-slide exposure based on a TTL reading will prove adequate for these and for many other cloud formations. Of course, you have to keep in mind that the exposure is being made for the clouds and not the foreground, which will most certainly be underexposed.

The sun behind clouds creates some startling contrasts. Again a TTL exposure works well. If the sun breaks through the clouds, shoot at minimum aperture for a star effect.

During a recent trip to San Juan, I noticed the moon's reflection in the ocean. I realized that I had only a few moments to capture the scene before the moon rose too far, resulting in too large an area of darkness. I chose a 180mm lens and made a TTL exposure with my camera in the aperture-priority mode. The exposure was f/2.8 at 1/15–1/30 sec. The moon is overexposed, but I think that's part of what makes this shot effective.

The moment I saw this cloud, I knew that I had to photograph it. I made several shots using my camera's TTL system. I bracketed no more than half a stop on the plus side. I found that both exposures accurately captured the grandeur of this cloud.

New Hampshire's White Mountains are often covered in mist at the higher elevations, but here the mist forms a low-lying fog. Fog tends to cause a reflected-light meter to underexpose. I like the effect in this shot, though: it reveals more texture in the scene.

Fog and Mist

These phenomena are composed principally of water vapor. Actually a low-lying cloud, fog is much denser than mist, and more reflective. You'll have to judge the reflectivity to determine how much exposure compensation is necessary, but one stop more than that indicated by a reflected-light reading is a good starting point, then bracket.

Lightning

If you are safely out of the reach of these powerful bolts of electricity, your only other potential obstacle when shooting is the rain that usually accompanies lightning. There are, of course, electrical storms unaccompanied by precipitation.

Use an ISO 64 to ISO 125 film for best results, and set the camera for a manual bulb exposure (B). Use a cable release for the shutter. An aperture of between f/5.6 and f/11 should work well. Point the lens well away from bright lights,

although street lights in sparse numbers will have a negligible effect. In cities, you'll have to limit the focal length of the lens and may even have to use a short telephoto to keep extraneous light from ruining the picture. Leave the shutter open for as long as it takes to record one, two, or as many bolts of lightning as you wish. But be aware that sheet lightning, which lights up the sky from outside the field of view of your lens, may cause overexposure, or at least, diminish the starkness of your images.

The most difficult part, perhaps, is the patience you need waiting for a bolt of lightning to appear within your lens's field of view, unless your lens is an ultra-wide-angle. Make sure that the locking or electronic release you use permits timed exposures. If you have to shoot in the rain, protect the camera—even from an indoor vantage point, with shifting winds droplets can fly your way through an open window or door.

Rainbows and Crepuscular Rays

Light-scattering by fine airborne particles results in the formation of crepuscular rays, whereas the formation of a rainbow is optically more complex, involving both the reflection and refraction of light. Exposure for either phenomenon is straightforward, with underexposure intensifying the effects. A TTL or hand-held averaging reflected-light meter will give you some underexposure to begin with. Closing down half a stop to two-thirds stop will further enhance the colors in a rainbow and the apparently converging rays. A polarizer also helps to intensify the rainbow's colors.

When I saw this rainbow, I made several exposures, letting the sky dictate a TTL exposure to saturate the colors (photo directly above). Although the rainbow didn't prove to be too interesting, the airplane added an additional focal point. In the shot at the top of this page, a TTL exposure enabled me to capture these early evening crepuscular rays over San Juan.

Snow and Sand

For many photographers, there is nothing like the pristine beauty of a fresh snowfall or a sandy beach. But this beauty produces major exposure problems. Under bright sunlight, snow or sand can be as blinding as the sun itself.

Reflected-light readings made of the snow or sand, especially under bright daylight, tend to result in underexposure. In the shade or under a heavily overcast sky, fallen snow is not bright enough to cause serious underexposure, however. Two factors to consider are: how much area is being occupied by the snow and whether the snow scene itself is your principal subject, rather than a person or animal standing in the snow.

The squint factor applies here (see page 28). Snow under a bright sun makes you squint heavily, underexposure could be serious, and you might need to adjust exposure as much as 1 or 1½ stops (more for negative film). If the squint factor is slight, then open up no more than one-half stop. In each case, bracket, because the intensity of the blueness in the snow and the detail of its texture will vary with exposure. More exposure will decrease both the blueness and the detail whereas underexposing will accent the texture and maintain more of the blue cast. (The blueness can be corrected with filters, of course.)

The heavy amount of blue results from a prevalence of ultraviolet radiation bouncing around. You can correct the color by using a skylight filter or an 81A warming filter, but be careful not to overwarm the scene. People naturally associate a blue tinge with the cold of snow; "warm" snow looks unnatural.

Ice can be as brilliant as a mirror, and glaring hot spots can cause your meter to underexpose by as

Knowing that the snow would cause appreciable underexposure, I bracketed this scene (top photo) on the plus side, in half-stop increments. While the +1 exposure did a fairly good job of restoring the bright tonalities, the +1½ exposure below looks truer.

much as two stops—the same as the brilliant sun it is reflecting. While underexposure of the image of a sheet of ice hides the nature of the ice, it reveals its surface texture. If your principal subject is within or adjacent to the glaring spot, open up 1 to 1½ stops to show detail in the subject and not leave it in silhouette; more than that would make the hot spot too intrusive. You can also try pointing the camera or your hand-held meter away from the hot spot, or any other brilliant area, to see what your exposure reading would be then, and use that.

While sand may not be as brilliant as snow or ice, the squint factor that applies to snow applies equally to sand. The only difference is that few scenes are as totally enveloped in sand as they are in snow. As a result, exposures that include a sandy beach, for example, are likely to include a good deal of sky and water, as well. But if you do find it necessary to photograph anything surrounded by bright sand, open up 1 to 1½ stops—more so if the sand is blinding and you squint hard. For closeups, the brilliance of the sun will probably be neutralized by the angle and how close you are working. There, the beach, which obtains its sheen from the glancing reflections of light, resolves itself into merely individual grains of sand. On the other hand, there are beaches where the sand is really white and the exposure dilemma may be more serious, even close to the subject.

A scene like this doesn't often appear in a camera's viewfinder. In order to get the image I wanted, I attached a 300mm lens to my camera, which was mounted on a tripod. I focused on one small area of the snowy mountainside and bracketed exposures on the plus side.

Closeup Photography

Adding close-focusing capability to your camera opens up a world that otherwise remains hidden or obscure, often overshadowed by the vast immensities surrounding us. But the newly revealed diversity of detail, texture, and tonal or color relationships that you now see do not come to you without exacting a certain price. Available-light closeup photography (to half-life-size or greater magnifications) severely limits depth of field and magnifies all movement of the camera and of the subject to the point where what might otherwise have been acceptable dissolves into blur. Camera shake is one culprit; another is the subject's moving out of the plane of sharp focus or simply to and fro, with even the slightest breeze or the photographer's misplaced breath.

The tools for closeups are basic: a macro lens (some manufacturers call theirs "micro" instead) will often suffice by itself, or a standard lens with extension tubes or plus diopter lenses. You can get fancier with a bellows and special micro lenses designed specifically for photomacrography. These special lenses are often not useable out to infinity and offer flatness of field, a feature more suitable for copying flat art and documents than for three-dimensional subjects. Where necessary, there are special flash units available to help you get the job done right.

Available Light

My favorite lens for closeup photography is in the short telephoto range. Most macro lenses are 50mm optics, but there is at least one that reaches out to 200mm. I prefer macros in the telephoto range because they give you more space to work in, especially with finicky subjects that

You can achieve a lifesize image a number of ways. I prefer to use my 90mm macro lens with its special lifesize adapter; this is simply an extension tube that yields 1:1 magnification. In this photograph of a monarch butterfly, I worked by available light, hand-holding my camera on a breezy day. I shot at f/2.5 at 1/60–1/125 sec. with my camera in the aperture-priority automatic mode.

barely tolerate the few millimeters of breathing space between them and the lens.

The one problem with tele-macro lenses is that ambient-light conditions may not permit you to hand-hold the camera without resorting to fast films or a tripod— or flash (see page 65). Experience has shown me, however, that the lens-focal-length-reciprocal rule works well, as long as the subject itself isn't moving. What I also find myself doing is shooting with the lens wide open. Using maximum aperture often works well when I want soft backgrounds for flower subjects, but it is troublesome when the subject is an insect on a windblown blossom. Here, the motion of the flower pushes it and my subject outside the zone of sharp focus. Now, having discovered the benefits of TTL flash, I find myself at a crossroads in my closeup photography, opting to use flash when I can.

Flash

Dedicated TTL flash measurement has taken the worry out of moving in too close with many of today's 35mm SLR cameras. While exposure errors can still occur, knowing that the dedicated electronic circuitry and microprocessor technology combine to inform you of the error does away with much of the disappointment you might have otherwise felt when you got your pictures back from the processing labs. Now exposure errors can be corrected on the spot, before they actually happen.

You may not have the good fortune to own such a system, however. Instead you may find yourself having to use an automatic flash unit with some exposure compensation or to switch to the manual mode to accommodate the extremely short distance between flash and subject.

You might also find that the trusty flash unit you've relied on until now is not even the right one for the job at hand. It wasn't designed to do this type of shooting and, while it could be adapted for this purpose, it might not serve as well as a unit

Available light did not allow for extended depth of field in this closeup of mating butterflies, which remained coupled in flight. The leaves in the background provided a compositional element. Deciding to sacrifice full sharpness, which would have been possible in a straight-on shot, I photographed the butterflies at an angle.

A lens-reversing ring lets you mount the lens backward. Although you have to be more careful (you can't add a lens hood to what has now become the front element), you can extend your closeup limits considerably. For this shot, reversing a 28mm lens enabled me to capture not only the dandelion's tiny florets but the insect feeding among them.

For this shot of a lizard in a small enclosure at New York's Bronx Zoo, I placed a front-mounted twin flash on the lens, positioned the units on opposite sides of the mounting ring, pressed the flash tubes against the glass to prevent reflections, and made this TTL flash exposure. The light coverage is fairly uniform, the depth of field is increased, and the lizard's coloration looks accurate. (Note the double catch lights in the lizard's eye.)

expressly designed for closeup photography.

Basically, the problem is that a flash seated in the camera's hot shoe finds the lens barrel blocking the path from the light to the subject. This results in a shadow on the subject. At magnifications as great as half-life-size, I've encountered no problem. But I wouldn't consider going beyond that point with the flash in this position. Another problem is autosensor parallax: the sensor may not be reading the light from the subject.

If you take the flash off the hot shoe to move it closer to the subject you are left with another problem: you may have exceeded the near limit for that flash. The result: you've just halved its effective output. In other words, the flash unit's guide number is cut in half for any exposure calculations you do. And the oddest part about it is that flash units designed for closeup photography also have a near limit that does not take you as close as

you want to go. But an autosensor mounted on the front of the lens (either with an accessory adapter or as part of a closeup flash) may give you a reliable reading. Manual flash requires calculation and experiment. Bracket around the *f*-stop recommended for the flash unit's near limit.

Specially designed closeup flash units, including ring flash and twin flash configurations, offer considerably greater control over the situation. The lighting provided may or may not be shadowless, and some units offer greater control than others. But non-TTL units still have closeup limitations in terms of subject to flash distance, just as conventional flash units do.

A more practical approach is to opt for TTL flash. Here, even a conventional TTL flash, positioned off-camera, can be used, as well as front-lens-mounted systems.

Extending Your Closeup Limits
The barrel of a macro lens extends out farther than that of a normal

lens. It may also be marked in magnifications (reproduction ratios) and lens-extension factors. This information saves you time in arriving at these figures through time-consuming calculations.

One other required piece of equipment is a ruler (marked in inches and millimeters) to measure the subject's size and its distance from the camera. Not every lens gives you exposure-correction factor data; in fact, for those that do, the data provided may apply only when a matched special extension tube (a lifesize adapter) is used. Remember, when using any lens extension with a wide-angle lens, don't use a lens shade. The shade could block out some of the light, casting a shadow on the subject.

TTL exposure metering is helpful here. The camera automatically compensates for the lens-extension factor. If you use a hand-held meter, however, you'll have to factor in the value manually: open up one stop for a factor of 2, or two stops for a factor of 4, and so on.

Plant, Insect, and Animal Closeups

Taking closeups of small plants, insects, and animals involves variables that you don't encounter when you shoot closeups of still-life subjects. Plant stems and branches sway with the wind; when animals stand still, they often will not do so for long. And, if you are shooting an insect at rest or feeding on a plant, you have to contend with the motion of the plant as well.

In addition, low light may call for flash, and magnification factors may require changes in lens extension or closeup lenses, which time may not allow for. These variables might mean the difference between success and failure with a particular subject. For an area teeming with small wildlife, you should have a macro lens that focuses to lifesize or half-life-size, a telescoping extension tube, or bellows to give yourself some flexibility. On the other hand, limiting yourself to a specific range of subject sizes (and image magnifications on film) would mean that you had less to manipulate. You won't have to rack a macro lens out or in more than a turn or two of the focusing ring, or work both the lens and the bellows or telescoping extension tube.

In order to anticipate other needs, mount the flash unit on the camera in advance. While you don't have to leave it on, which would exhaust the batteries, turn the unit on to charge up the capacitors before shooting. This way, you won't waste time waiting for the flash.

Flowers and Other Small Plants

The principal points of focus in closeups of flowers are usually the stamens and pistils. You may find yourself having to focus on one or the other if the film speed and light levels do not permit sufficient depth of field. Only part of the petals may be in focus under these conditions, but the softness of the colored background is often effective.

Outdoors even the slightest breeze can either blur the subject or cause it to move out of its optimum position in your composition.

Just as I was about to photograph this elusive butterfly, it started raining heavily, but I persevered. I made these exposures at f/8 and f/11 with a TTL front-mounted twin flash system and a 90mm lens at half-life-size.

In this shot, I used a front-mounted twin flash and was able to stop down the lens to f/22.

Because any breeze can be a potential problem with flowers and leaves, you have to consider whether your film is fast enough to allow you to shoot at the optimum aperture and shutter speed or to use a faster film. You can also opt for flash to give you both good depth of field and motion-stopping capability. But the low power output of many flash units designed for closeup work can still make a faster film necessary to enable you to use an aperture of $f/22$ or $f/32$ to get the greatest depth of field possible from your lens.

Remember that movement can occur backward and forward as well as side-to-side, and it's often diagonal. When the plant starts to sway, the best thing to do is to wait until the breeze hits a lull. Have your camera ready, with your finger poised on the shutter release and gently squeezing down on it. You won't have much time, and flash won't help, except possibly to prevent blur from movement: the breeze will move the subject from point to point in the picture field, if

not out of the picture field entirely. In steady wind, the flower at least remains in one plane, not swaying in different directions. In either case, you might be able to control the wind or breeze by blocking it with your camera bag or yourself— as long as you don't cut off the daylight needed for the exposure or for the lighting effect you planned.

You will also find that when you focus very close on flowers, your TTL exposures are usually correct. If the color of the flower is a bright white, yellow, or pink and it dominates the finder area, however, compensate for possible underexposure by opening up one-third stop to half a stop. However, slight underexposure will bring out more detail in the petals. If you're close but not close enough to fill the frame with the entire flower, or if you're photographing a cluster of small white or yellow flowers, watch the background and be prepared to adjust your exposure. A highly reflective backdrop or a cluster of bright-toned blossoms could cause the meter to underexpose your

Shooting closeups of flowers in available light can be difficult because of the large apertures needed. This results in shallow depth of field, as shown here.

WILDLIFE CLOSEUPS

Small reptiles and amphibians respond to the vibrations that your footsteps put into motion. You hear the little creatures scurrying off long before you see them. Frogs in the water will vanish below the surface. Your patience will be rewarded, however, when they resurface. Small lizards that blend into their surroundings will return to a spot, perhaps because they are territorial. Early morning will find them basking in the sunlight to soak up the warmth they require for metabolic processes—a good time to photograph them, if you can see through their camouflage.

Insects feeding on nectar never remain at one flower for long, probably as a defense mechanism, but certain flowers will attract nectar feeders in droves. When the insects copulate, they remain bound together for a considerable length of time. Mating ladybugs crawling along a leaf are bound to each other, and butterflies often take to the air together. When they are feeding or mating, many insects appear oblivious to the camera, as long as you don't interfere with them: be careful not to bump into neighboring branches or to allow any piece of equipment to hit the plant the insect is using. Of course, insects notice anything that passes their field of vision; if you move around, do so very slowly. They may also notice a sudden drop in light or temperature caused by your shadow falling on them.

These lizards were scampering about, practically underfoot. But I didn't have to wait too long before one approached me. I took this portrait using a TTL flash. The setup consisted of an 80mm macro lens with telescoping extension tube and a compact TTL flash, which I held out to one side of the camera and aimed at a slight angle to the subject. The exposure was made at f/5.6.

I found the coral-like shape of this fungus attractive. I made TTL flash exposures using a macro setup at f/5.6. Hand-holding the flash unit was a bit difficult in hot, humid weather. A flash bracket would have been helpful.

principal subject. Of course, the reverse is true, and a too-dark background or a black flower might result in overexposure.

I have often found that an exposure for a brightly colored flower will render the background dark, unless there are other light-colored flowers or shiny leaves to reflect some light. The effect actually resembles a flash exposure made with a small *f*-stop, except that the lens apertures in the pictures I've taken by ambient daylight are usually at or near maximum.

Other potential plant subjects include fungi, lichens, mosses, and similar plant life. Patches of light-colored lichens or groupings of white or off-white mushrooms can throw the meter off toward underexposure by about half a stop. Mats of moss and related species shouldn't be a problem, but the fruiting bodies of both mosses and lichens might be if viewed against a

bright background because they stand up higher from the ground.

Insects and Small Animals

Unlike plants, most animals are not rooted to one spot. Some move about continuously, while others remain still for relatively long periods. Their activities are guided by basic survival needs: feeding and reproduction. For many, the need to avoid predators is present in every waking—and sleeping—moment. Some rely on natural camouflage, some on speed and keen senses— or both—to capture prey or to avoid capture. Others announce themselves blatantly, through their coloration, to be toxic or dangerous. No matter how blatant the animal's warning signs or how well camouflaged it is, getting too close to it will, as with larger forms of wildlife, elicit the fight-or-flight reaction. Few species will disregard your presence entirely.

Exposures are generally no

Photographed with a 90mm lens and telescoping autoextension tube for a slightly larger-than-life-size image, the crisp detail and stark colors of this red-eyed fly prove that using flash does have its advantages. I used a front-mounted twin flash TTL system for this f/22 exposure. Even with the flash, a breeze made it necessary to take several shots.

problem, but watch for bright backgrounds that tend to cause underexposure of the main subject. Even a bee feeding on a red flower illuminated from behind may be underexposed: the transilluminated petals will look brighter to the exposure meter than they really are. In such a case, open up one-third stop to half a stop to ensure for correct exposure of the insect. For a frog surrounded by bright reflections in the water, open up one-half to one stop, depending on the relative brightness of the reflections.

Still Lifes and Copying

I shot this still life of fruit in a street fair stall. I hand-held my camera and stopped down the 24mm lens to f/5.6. The shade provided fairly even lighting, which helped prevent harsh contrasts. The small amount of direct bright daylight playing off the edges of the bananas would have been a problem if it had been stronger or had intruded into more of the subject area.

The essential ingredient to the successful creation of a still life is a key-light to fill-light ratio that holds detail in the key areas of the principal subject or group of subjects. (Remember, *ratio* expresses the comparison of the brightest and darkest areas of a subject. The higher the ratio, the more "dramatic" the light/shade effect; the lower, the "flatter.") The lighting ratio may be 1:1, with no lighter or darker side, or it may be a little higher, 2:1 or 3:1, to hold detail but appear more three-dimensional because there will be heavier shadows to model the forms. With copying, the lighting must be strictly flat, 1:1, so that all areas of the work being copied are equally readable to the eye.

Still Lifes

These can be made or found. My favorite still lifes are those I find outdoors. I often look for soft lighting and a pleasing compositional relationship among the colors, shapes, and textures. Some still lifes require a great deal of time and patience, as well as an eye for designing compositions from scratch. They also require more lighting equipment, and a view camera is often essential.

Effective still lifes demand careful control over lighting. You can work with one light or several, using reflectors to fill in where more illumination is needed. Soft lighting from a light bank, for example, may work best with some subjects. In any case, make sure that light placement suits the subject.

Highly reflective objects can be photographed inside a light tent, which is a conical, translucent diffuser that has an aperture at the top for the camera to peer through. The lamps, generally two, are placed at an angle to each other, pointing at the front of the diffusion tent. The light inside the tent is usually soft and even, with virtually no glaring hot spots, but metallic objects may need dulling spray.

For glassware, the most effective lighting is transillumination. The light can be bounced off a reflective background or aimed directly at—or, with one light at either side, at an angle to—a sheet of semitranslucent plastic that serves as a backdrop for the glassware. Colored lights add sparkle to the glass.

Painted glassware, however, requires fill light at the front to bring out the artwork. Try different lighting for different effects. But make sure that the backlight does not shine directly into the lens, or it will result in flare. When illuminating glassware, another option is to use a commercially available transillumination table, which may look like a large chair with a frame covered in a sturdy, white semitranslucent plastic.

Closeup Still Lifes

Some still lifes require a combination of good lighting technique and closeup photography. Small objects, such as miniature figurines, jewelry, and many seashells, require close-focusing (macro) capability in your lens. Experiment with a a ring flash or a twin flash system mounted on the front of the lens as a light source. More often you will use a light tent or a fiber-optics light system.

What you have to be careful of here is background shadow: because the backdrop is close to the subject, the flash may cast obvious and deep shadows onto the background immediately behind the subject. Either light the background separately or make sure that it is far enough away from the subject that shadows don't catch on it.

Copying

Photographing flat objects—for example, copying old family pictures—requires a lens with good edge-to-edge sharpness and a lighting setup that gives flat, even illumination all over. Special copy stands are available that have a baseboard—to hold the flat copy—and a pair of tungsten lamps on adjustable arms that can be moved to give uneven lighting for small three-dimensional objects. But any lighting system will do for copying if it gives you a 1:1 lighting ratio. For the object to be rendered not only flat but also truly proportional to the original, the camera must be positioned perpendicular to the object being copied. Otherwise, rectangular documents will appear keystone shaped.

One problem is visualizing the effect. Portable electronic flash units don't let you see the lighting effect in advance, even though you can measure the amount of light output with a hand-held flash meter. For that reason, it is often simpler to use electronic flash units that have modeling lamps or tungsten lights—or even fluorescent lighting. Being able to see the effect in advance tells you whether any glaring reflections exist and whether a polarizer can help. One copying arrangement I've used involved placing a heavy sheet of glass over a document to keep it flat, with a fluorescent lamp fixture at either side. It was important to see the effects of the light and to make sure the lens would not see any glare or reflections.

Determining Contrast and Exposure

A visual check on contrast may be all you need to use with a studio flash lighting system with modeling lights or quartz-halogen lamps. But you can always take a reading with an incident-light meter, using the flat diffuser. More important, be careful that certain areas are not too light or too dark. To do this, make a brightness ratio reading of the key light and dark areas directly with a spot meter (don't make a gray card reading). If the brightness ratio is more than 4.1 (a two stop difference), you'll need to rearrange the lights or add light to fill in the dark tones.

Contrast control for copying is much easier. Take a spot reading of a gray card at each corner and crisscross the document to make certain that the lighting is uniform throughout. You can also use an incident-light meter with a flat diffuser in a similar way.

Making an exposure reading depends on the lighting arrangement. With lights directed at the subject from all sides or mainly from the back (as with glassware), a reflected-light reading may be easier to work with; with the key lights coming from a frontal direction, use an incident-light meter. For tent lighting, center a gray card in the bottom of the tent, and then take a TTL reading for continuous light or a hand-held reflected-light meter reading for flash. You can also use an incident-light meter inside the tent. Follow the same procedure outlined for tent lighting to determine exposure for copying applications.

Adjust your lighting so that you have a good depth of field to cover the subject front to back. If you're working with a continuous light source, be careful to avoid reciprocity effects with unduly long exposures.

Film Choices

Having mentioned light sources other than those that are daylight-balanced leaves you with some "ominous" choices. With daylight color film, use flash or work outdoors in the shade, or on an overcast day, for more even lighting, use the proper filter. For tungsten lighting, use a tungsten-balanced film or add a conversion filter for the 5500K film of your choice. But with fluorescents, short of using a color-temperature meter for an accurate assessment for filter choices, you can just shoot black-and-white film. On the other hand, if you've had enough experience with both fluorescent-to-daylight filters and the lamps you're using to trust that approach with a daylight color film, then go for it.

INDEX

Editorial Concept by Susan Hall
Production by Ellen Greene